Rick Sammon's
FIELD GUIDE
to Digital Photography

Rick Sammon's

FIELD GUIDE

to Digital Photography

Quick Lessons
on Making Great Pictures

Rick Sammon

 W. W. Norton & Company New York • London

For information about permission to reproduce selections
from this book, write to Permissions, W. W. Norton & Company, Inc.,
500 Fifth Avenue, New York, NY 10110

For information about special discounts for bulk purchases, please contact
W. W. Norton Special Sales at specialsales@wwnorton.com or 800-233-4830

Manufacturing by RR Donnelley, Shenzhen
Book design by Carole Desnoes
Production manager: Devon Zahn

Library of Congress Cataloging-in-Publication Data

Sammon, Rick.
Rick Sammon's field guide to digital photography : quick lessons on
making great pictures / Rick Sammon. — 1st ed.
p. cm.
Field guide to digital photography
Includes index.
ISBN 978-0-393-33124-0 (pbk.)
1. Photography—Digital techniques—Handbooks, manuals, etc.
I. Title. II. Title: Field guide to digital photography.
TR267.S2675 2009
775—dc22

 2008032365

W. W. Norton & Company, Inc.
500 Fifth Avenue, New York, N.Y. 10110
www.wwnorton.com

W. W. Norton & Company Ltd.
Castle House, 75/76 Wells Street, London W1T 3QT

1 2 3 4 5 6 7 8 9 0

For Captain Jack
Don't you just love it?

Contents

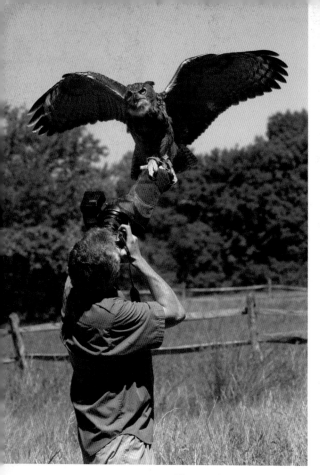

Photographs by Susan Sammon

Introduction

This introduction is the shortest I've written for any of my books. That's because this is my shortest book!

Despite its small size, I've packed this book with my very best photography tips and techniques—most compiled and condensed from my other books. To keep things fresh, I've added new pictures and updated my "digital speak." Technology has changed, and I've changed some of my digital shooting techniques.

The book is designed to fit in your camera bag. You can take it with you on your journeys to exotic lands as well as on family vacations.

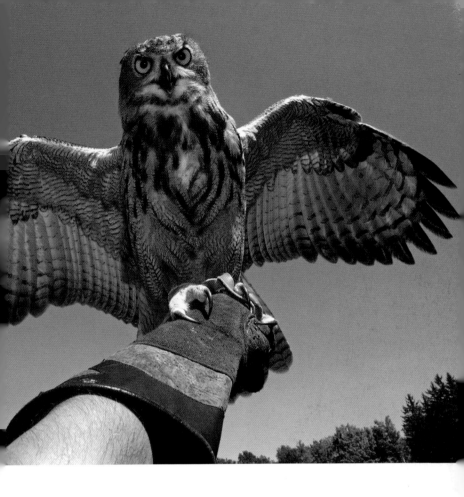

 As I mention in all of my books, feel free to contact me if you have any questions or if you want to share a photograph. Just send me a low resolution JPEG file (72 pixels per inch, 5 x 7 inches) at ricksammon@mac.com.

 When reading this book, remember my all-important message: Have fun when you are taking pictures! If you have fun when you are shooting, as I did during my photo session with the African eagle owl, you'll get more satisfaction out of your photography, and better pictures.

 Read on and have fun!

Rick Sammon's

FIELD GUIDE

to Digital Photography

Working with
Digital Images

Digital photography is magical to me, especially when I get a picture like
the one of a young girl that I photographed in a remote village in Bhutan.
Seeing my pictures immediately on my camera's LCD monitor, and

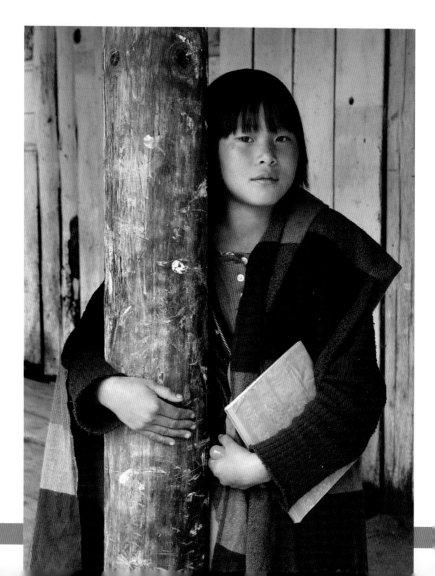

then seeing them on my computer, keeps the magic alive. And, of course, part of the magic is sharing my pictures with the people I photograph.

This magic, however, can turn into a cruel disappearing act. The screen shot here shows how a corrupt file looked on my monitor when I tried to open it in Adobe Camera RAW.

What caused the problem? A brand new memory card reader was the culprit. After switching card readers, I could see my file.

So here's the first tip in this lesson: Test each and every piece of equipment before you go out in the field. If you are already out in the field, try to do a test with some snapshots before working with your great shots!

By the way, if it looks as though your files are corrupted, they may be okay. You may be able to recover them with the image rescue software that comes with your memory cards, or other software recovery programs. In addition, downloading your files directly from the camera eliminates the variable of a memory card reader. However, I always use a memory card reader to download my files, because it's faster than a camera-to-computer download.

In this lesson I'll cover a few more do's and don'ts for handling your digital files.

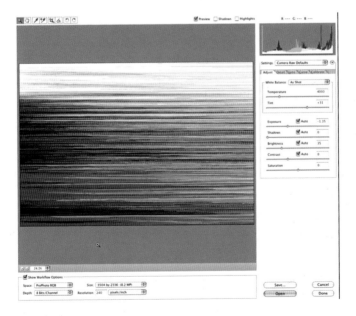

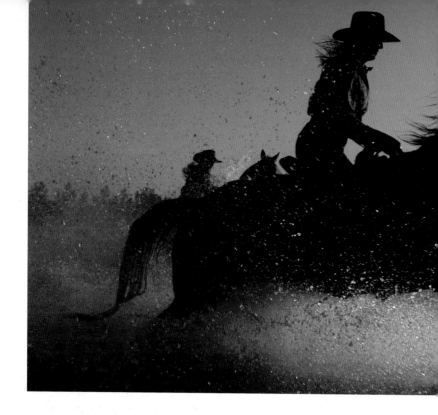

In-Camera Deleting and Formatting

At the touch of a button, we can easily delete an "outtake." However, Adobe Photoshop and Adobe Photoshop Elements (as well as Apple's Aperture and Adobe's Lightroom) can rescue outtakes, and sometimes even turn them into works of art. Don't be so quick to delete an image. This picture of a horse and rider started out as an outtake. The horizon line was tilted, the water was overexposed and the color was off. After a quick Photoshop session, I turned the shot into a keeper. Keep Photoshop in mind, and you'll have more keepers than you think!

To use a memory card efficiently, it's essential to format it each time you put it into your camera. Formatting wipes the card clean. Merely deleting files leaves some picture information on the card.

Before you format a card, make sure your pictures are stored in at least two places, because one place (CD, DVD, or hard drive) could become corrupted. And before you start taking pictures again, check your camera's LCD display to make sure it says, "No images on card."

No Images on Card

Portable Hard Drives vs. CDs and DVDs

Portable hard drives are a good way to back up your pictures while traveling with a laptop. Transferring data from a laptop to a hard drive is much faster than burning a CD or DVD, which is a big benefit when you take a lot of pictures, especially RAW files.

When you get home, you simply plug in the portable hard drive to your main computer for data transfer.

CDs and DVDs are a safe way to permanently store your pictures, because unlike hard drives, they have no moving parts. That said, if a CD or DVD gets scratched, it might become unreadable.

If you store your pictures on hard drives, as I do, you need to turn them on every few months. You can damage a hard drive by letting it sit for too long, and then your pictures could be lost forever.

Travel and Nature Photography Basics from A to Z

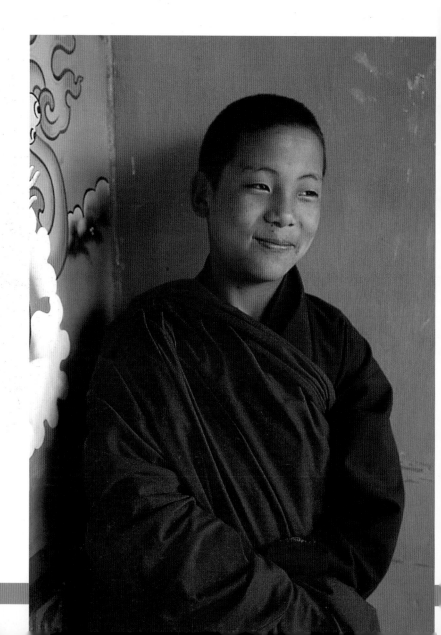

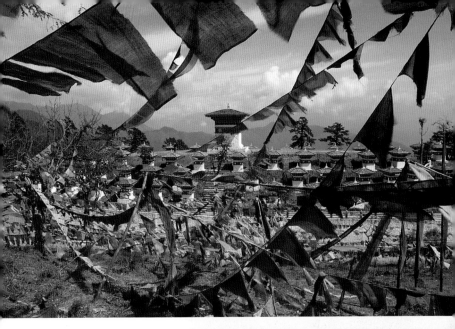

Are you in a hurry to soak up some photo know-how before you head out on location? I don't blame you! I can't wait to get out in the field and start shooting, too!

Before you go, always keep in mind that we, as photographers, are storytellers. To tell a location's story, take landscape pictures, portraits, and close-ups, as well as other wide to close-up views. That's what I did when I was in Bhutan. All these photos were taken with my Canon EOS 1Ds Mark III and my 24–105 mm lens. Zoom lenses help to tell the story.

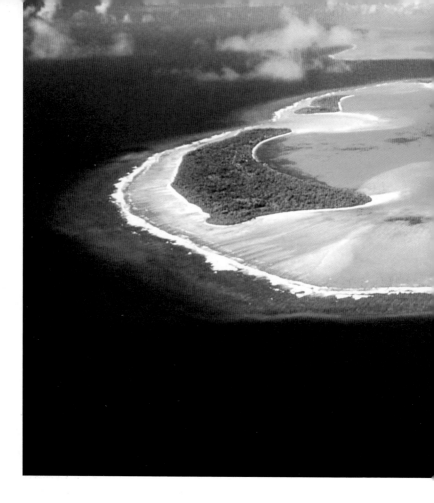

Aerials

Before you take off, ask the pilot where you should sit for the best pictures. Sometimes it's in the copilot's seat; sometimes it's in the back of the plane. It's never over the wing.

When shooting from a small airplane, you'll most likely be shooting through Plexiglas. If you have the opportunity and are not faint of heart, ask if the door can be removed for a sharp shot. To avoid reflections on the Plexiglas, cup your hand around your lens and hold it near, but not on, the window. Wearing a black shirt will also help reduce reflections. A white or light-colored shirt might create a bright reflection.

When taking pictures from an airplane, especially a small one, you

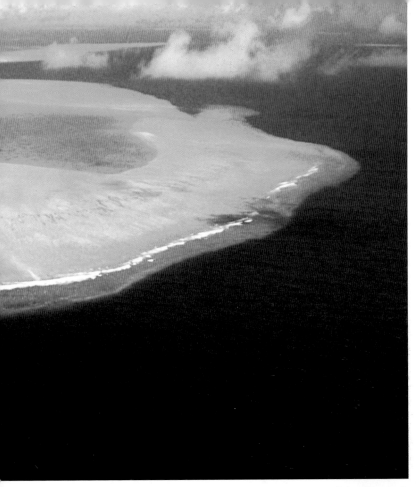

Palau, Micronesia

don't want any part of your upper body to touch the window or any part
of the interior of the plane. If your upper body comes in contact with, say,
an armrest, the vibration from the plane can be transferred to your
camera, causing camera shake, which, in turn, can cause a blurry picture.
To reduce the effects of camera shake, use an ISO setting that gives you a
shutter speed of at least 1/250th of a second. I usually set my ISO to 200
on a sunny day. When it comes to lenses, use a medium wide-angle
setting for sweeping views and a medium telephoto for tighter shots.

 When you are shooting from a small plane, be prepared to shoot fast!
Set your camera on rapid frame advance, and be ready to shoot at a
moment's notice.

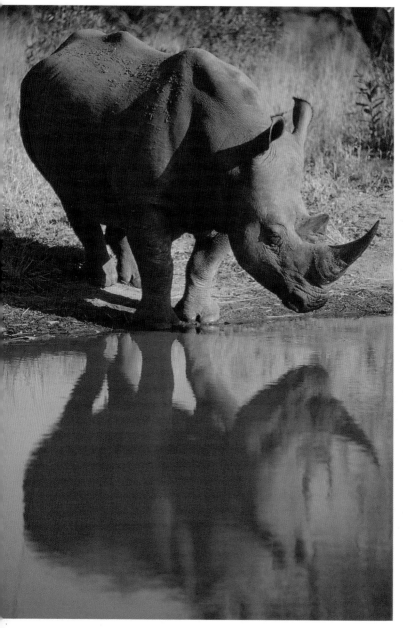

Behind-the-Scenes Shots

We all love to zoom in our subjects to get pictures with impact. But behind-the-scenes shots add a personal touch to slide shows and photo albums, giving the viewer the feeling of being there. I like to present both of these photographs in my slide presentations, because they show that I was in a safari vehicle when I took the shot of the white rhino.

South Africa

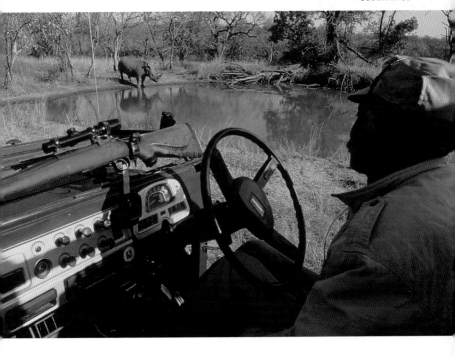

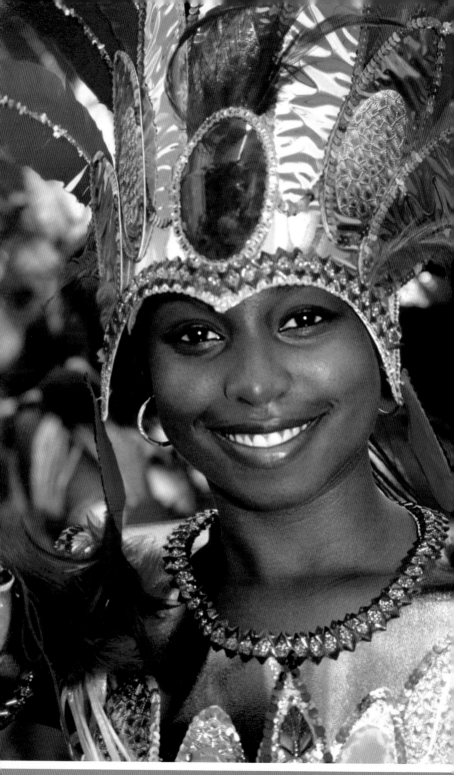

Caribbean Carnivals

Caribbean carnivals are great fun and offer great photo opportunities. You'll find hundreds of people dressed in colorful costumes. The key to getting good photographs of these celebrations is to actually join the slow-moving parades that pass through the streets, to walk along with the participants. To reduce harsh shadows caused by direct sunlight, use a flash for daylight fill-in flash photography. If you don't have a flash that offers variable flash output (necessary for these fill-in flash pictures), or if you don't want to use a flash, wait until the end of the parade (or get there early), and ask your subjects to move into the shade for a portrait. Keep in mind that carnivals are big, loud parties. I use earplugs to mute the volume of the music, but to best capture the mood of the event, you still have to get in sync with the party.

Carnival, St. Maarten

Deserts

Deserts, as well as beaches, offer two major challenges for photographers: bright sunlight and lots of sand. When direct sunlight falls on the front element of a lens, it causes *lens flare*. At its worst, lens flare looks like a bright, glowing point in a scene. At its best, it can make a picture look flat and soft. To avoid lens flare, use a lens hood, or shade your lens with your hand or a hat.

Sand can get into the focusing and zooming rings of your lenses; avoid it at all cost. *Never* place your camera bag down in the sand.

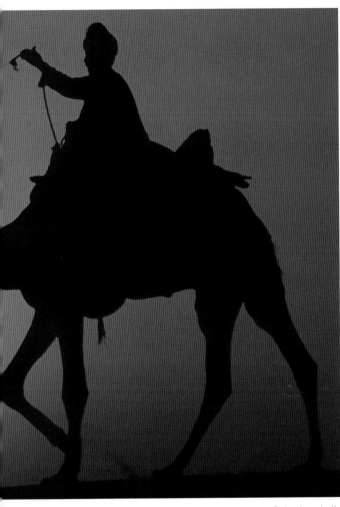

Rajasthan, India

When changing lenses in the desert or at the beach, find a place that is protected from the wind. The last thing you want is even a single grain of sand on your digital SLR's image sensor. This single grain will look like a large blob in your pictures. Also, change lenses very carefully. Once I was teaching a workshop on the beach when one of my students actually dropped a lens in the sand! Carry a small can of compressed air to clean delicate camera parts in such emergencies—but never spray it inside your camera.

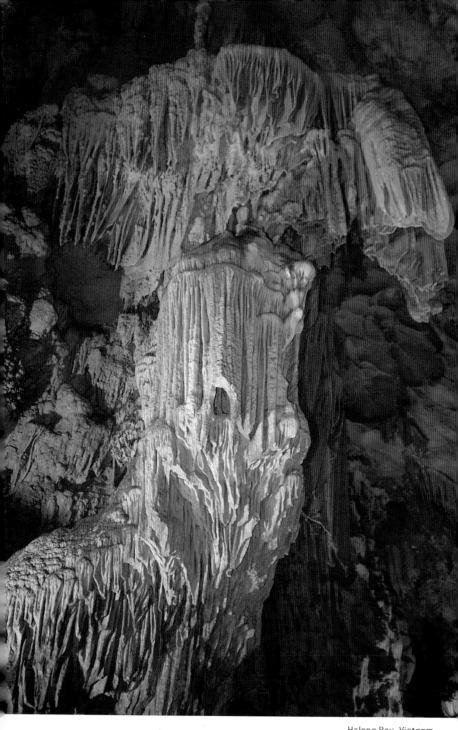

Halong Bay, Vietnam

Exploring a Location

Part of the fun of taking pictures is exploring a location. Being prepared to capture unexpected sites is a key ingredient in getting the best shot. On a trip to Halong Bay in northern Vietnam, I packed a variety of lenses and accessories, including my flash. Without my flash, and fresh batteries, I would have missed photographing this quite unexpected view: a massive cavern discovered accidentally by a fisherman a few years before my 2003 trip.

Fun Shots

It's easy to get caught up with taking the best possible pictures when we're on location. However, if we try too hard and don't have any fun, we may not get the best picture, or even get a high percentage of good pictures. My advice is to have fun! And when you are having fun, record the moment. In later years, your fun shots may mean more to you than your serious photographs.

Grand Canyon, Arizona

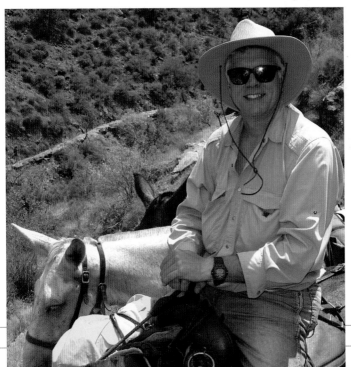

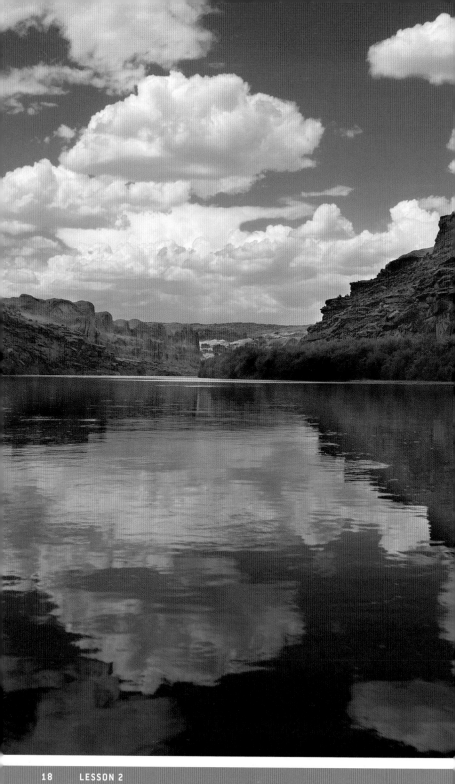

Glare on Water

The number one screw-on filter you need for outdoor and travel photography is a *polarizing filter*. A polarizing filter can reduce or even eliminate reflections on glass and water. It can also make outdoor pictures look sharper, because it can reduce atmospheric haze. Polarizing filters are most effective when the sun is off to your left or right. Screw-on warming polarizing filters, which have a built-in warming filter, are also available. A warming filter adds a red-yellow tone to a picture, and creates the effect that the picture was taken early in the morning or late in the day when the light is "warmer" than it is at midday, when the light is "cool."

Colorado River, Utah

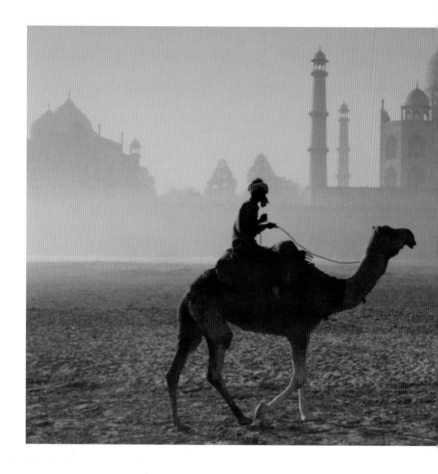

Heat and Humidity

Digital cameras don't like heat or humidity. When an image sensor heats up, the colors recorded may be inaccurate. If you have a digital SLR, don't change lenses once you've left an air-conditioned area until your camera has adapted to humid conditions. If you do, condensation can build up on the filter that covers the image sensor and fog your pictures. If your lens and viewfinder fog up, you can wipe them clean with a lint-free cloth or wait until they clear up.

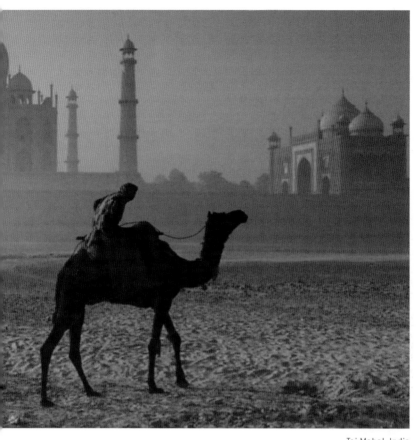

Taj Mahal, India

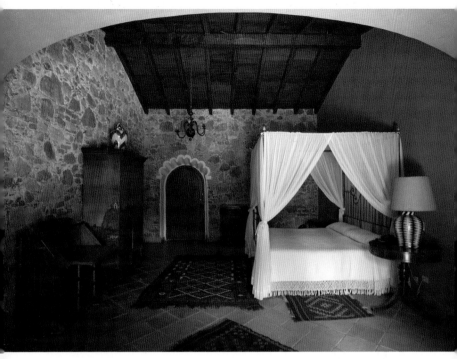

San Miguel de Allende, Mexico

Indoors

Whenever possible, try not to use a flash for indoor shooting. The harsh light from the flash will make your pictures, you guessed it, look harsh. If you do have to use a flash, bounce the light off the ceiling. In order to do that, you'll need a flash with a swivel head. Bouncing the light will spread and soften the flash for a more even and flattering effect.

For indoor, natural low-light photography, a tripod is sometimes a must. For hand-held pictures, you'll need to use a high ISO setting (maybe 400, 800, or even higher). This bedroom photograph is a natural light shot, taken with my camera mounted on a tripod.

To help steady my indoor shots, I use a Canon 28–135 mm image stabilization (IS) lens. This lens reduces the effect of camera shake, and lets me shoot at a slower shutter speed than is usually possible for handheld photography. The general rule for handholding a lens is this: Don't use a shutter speed slower than the focal length of the lens. That is, when using a 28 mm lens, don't use a shutter speed below 1/30th of a second.

Amazonas, Brazil

Jungles

Deep in jungle, we have to deal with dim lighting conditions. Be prepared to shoot at relatively high ISO settings, maybe even as high as ISO 800. Using a flash is another option if you plan to photograph people or wildlife close-ups.

Belize Zoo, Belize

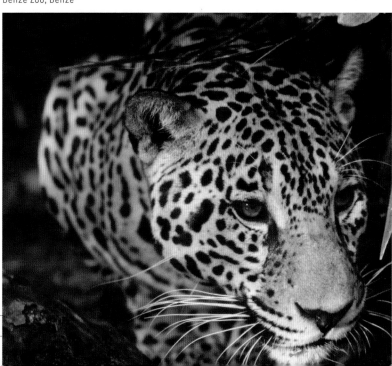

Tampa, Florida

Kids

When photographing kids while traveling, keep this saying in mind: "Silence is deadly." During an impromptu photo shoot, keep talking to the kids, even if you are using a translator. The feeling and attitude you project will be reflected in your subject. Another tip is to see "eye to eye," that is, get down to the child's level when you take your picture, rather than standing up and looking down.

Light the Eyes

In portrait photography, the eyes are the most important elements. Therefore, for a successful portrait, we need to light the eyes. We can do that with a flash (as I did for this photograph), with a reflector, or by repositioning the subject so the sunlight lights the eyes.

Venice, Italy

Angkor Wat, Cambodia

Mind Your Manners

When we travel, we need to respect our subjects and be respectful of local customs. When we respect our subjects, they will respect us, helping us get the kind of pictures we are seeking. Reading about local customs and religions gives us an understanding of what to expect on-site. I've found that most people will pose for a portrait if I ask their permission with a genuine warm smile. I also respect the person's right to say no.

Nighttime Shooting

Cities come alive with lights after the sun sets. This is a great time to get dramatic photographs. To capture the lights, I recommend setting your camera to ISO 400 and the White Balance to Automatic (to work with the different light sources). To add drama to nighttime city photographs, use a slow shutter speed (perhaps as long as 30 seconds) to get taillights streaking through a picture. Those long shutter speeds will require a tripod. Check your camera's LCD monitor to make sure that bright lights are not overexposed. If they are, use your camera's Exposure Compensation control and reduce the exposure accordingly. Finally, remember what your mother told you: Wear white at night for safety.

South Beach, Miami Beach, Florida

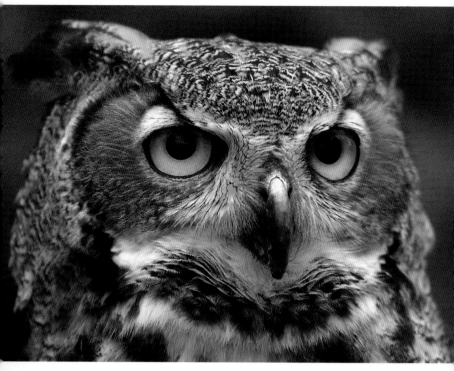

Anna Maria Island, Florida

Owls and Other Birds

For tight head shots of birds and other feathered friends in the wild,
you'll need a telephoto lens. For a basic "bird lens," I'd recommend a
100–400 mm zoom. To get an even tighter shot of a faraway bird, use a
1.4X or 2.4X teleconverter, which effectively increases the focal length
of the lens by 1.4 times and 2.4 times, respectively. To light subjects
that are in the shade and to add some catch light to the subject's eyes,
use a flash and a flash extender, a device that fits over the flash head
and increases the possible flash-to-subject distance.

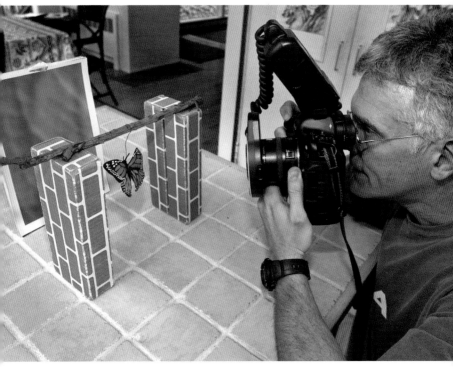

Croton-on-Hudson, New York

Practice at Home

When we go on location, we often see photo opportunities disappear in the blink of an eye. Fumble around with camera settings, miss the shot. I've seen that all too often in my workshops. Practice at home, to the point where making camera adjustments becomes second nature, and you'll get a higher percentage of keepers when you travel. Practicing, however, goes beyond technical camera adjustments. If you have not photographed strangers for a while, photograph your family, friends, and neighbors to start. If your travels will be taking you to a foreign city, make a trip to your local big city and practice shooting throughout the day. If close-up nature photography is your passion, spend time experimenting with lighting to see how best to illuminate your subjects. Taking pictures on location is like jazz improvisation: knowing what to do next becomes almost automatic.

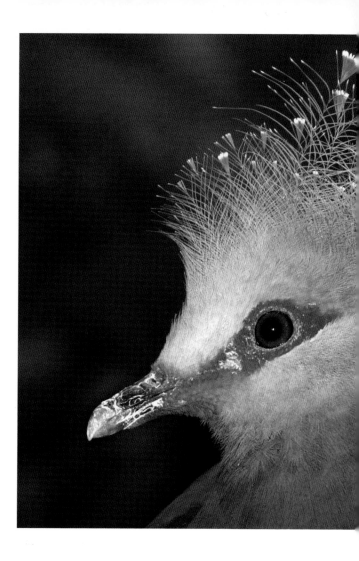

Quality Control

Novice digital photographers often think that getting a camera with the highest number of megapixels and shooting in the RAW mode will give them the highest quality image. Well, those factors do affect image quality. However, they are not the only things to consider. The quality of the lens affects both the sharpness of an image *and* how much light reaches the corners of the image sensor. When light is reduced in the corners, the image will look darker in those areas. How a digital file is processed in-camera also affects output quality. More expensive cameras usually have higher-quality image processors than relatively inexpensive

San Diego Zoo, California

cameras. How you process an image in your image-editing program also affects the quality. For best results in the digital darkroom, save and edit your pictures, including any editing on Layers, as TIFF files, which is a lossless way to save pictures. If your imaging program can open 16-bit files, go for it. You'll get less banding in shadow areas, and you'll have a file with maximum color depth. When sharpening an image, always sharpen as a final step, because adjusting the contrast of an image, as well as Levels and Curves, affects the image sharpness. Therefore, if you sharpen first, you may wind up over-sharpening the image.

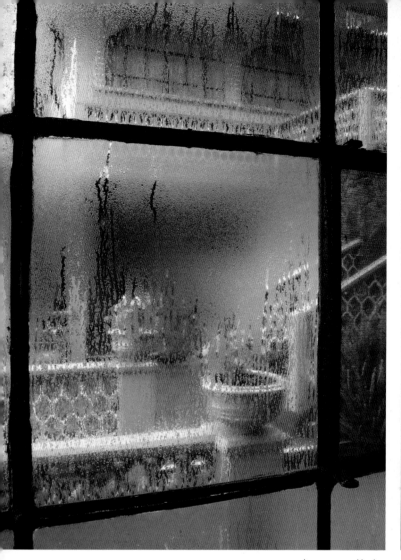

Anganguero, Mexico

Rainy Days

To protect your gear when shooting in the rain, travel with a camera bag that has a water-repellent, foldout cover. For in-the-rain shooting, use large sandwich bags or plastic bags with openings cut out for your lens and viewfinder. For serious protection, check out the waterproof plastic housings from ewa-marine. In any case, do not let your camera get wet! Digital cameras don't like moisture.

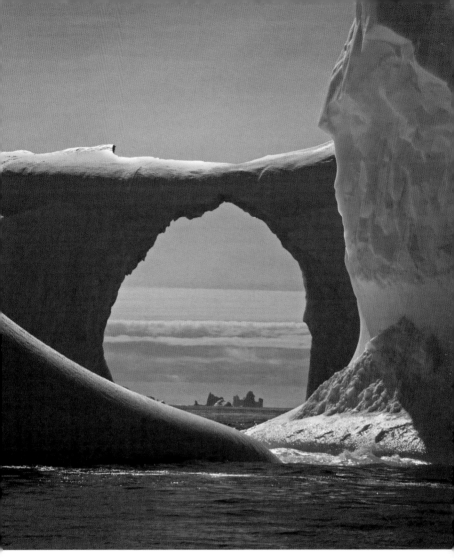

Antarctica

Shadows

Shadows add depth and dimension to our pictures. Without shadows, pictures look flat. Overcast days and scenes before sunrise and after sunset have few if any shadows. Sunny days offer strong shadows, with the most dramatic and flattering shadows in the early morning and late afternoon. For the most dramatic outdoor pictures, shoot during these hours, when the light is warm and shadows add contrast.

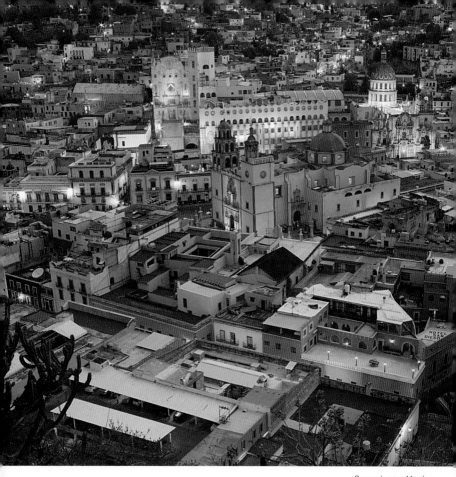

Guanajuato, Mexico

Twilight

Twilight is a wonderful time to photograph cityscapes.
The mixture of soft natural light and the city lights
produces pictures that seem to glow. When you arrive
in a foreign city, ask the hotel manager when the sun
sets and where most people go to photograph it. Get
there early, set up your tripod, and compose your
picture. Underexposing your pictures will give you
slightly more saturated colors. Set your White Balance
on Auto to best accomodate the mixture of light
sources. To help prevent camera shake, use your
camera's self-timer and a tripod for hands-off shooting.

Underwater Photography

Shooting beneath the waves requires waterproof cameras or waterproof housings for topside digital cameras. An internet search will help you find gear that meets your needs. Wide-angle lenses are ideal for beneath-the-waves seascapes. Lenses longer than 50 mm are relatively useless. To capture the wonders of the close-up world, you need a macro lens. To bring out the color of marine creatures, you'll need a flash (or two), because water filters out color. The deeper you dive, the more colors you lose.

Maldives

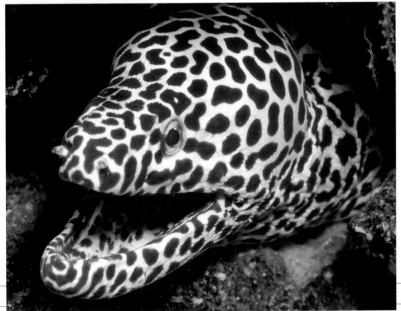

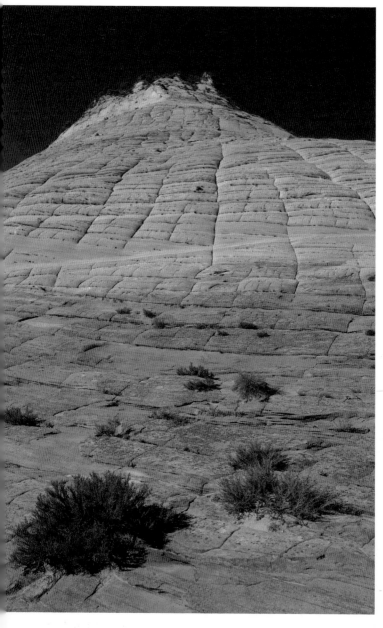

Vertical and Horizontal Shots

How we hold our cameras, vertically or horizontally, and how we compose our pictures in each position, greatly affects the impact of the resulting picture. What's more, if a travel photographer hopes to be published, having both vertical and horizontal pictures of the same subject increases his chances. When I am out shooting, I usually take both vertical and horizontal photographs of the same subject.

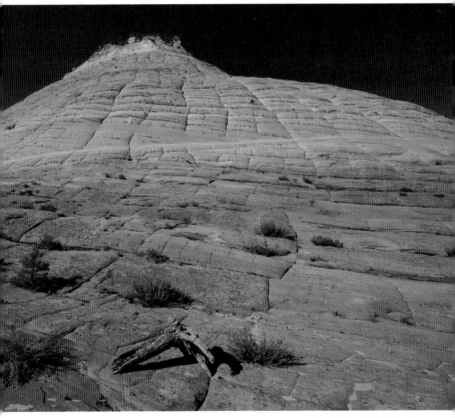

Zion National Park, Utah

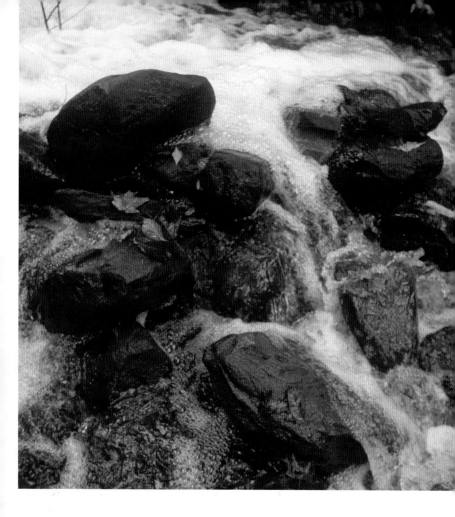

Waterfalls

Three technical factors to consider when photographing moving water are exposure, filtering, and shutter speed. Because water reflects light, you'll often see hot spots in waterfall scenes. To avoid these washed out areas, slightly underexpose your picture, perhaps by a stop. To reduce reflections in-camera, use a polarizing filter.

Use a slow shutter speed (from 1/15th second to as many as several seconds) to blur the movement of the water. The longer the shutter speed, the more the water will be blurred.

If it's sunny, use a neutral density filter. It reduces the amount of light

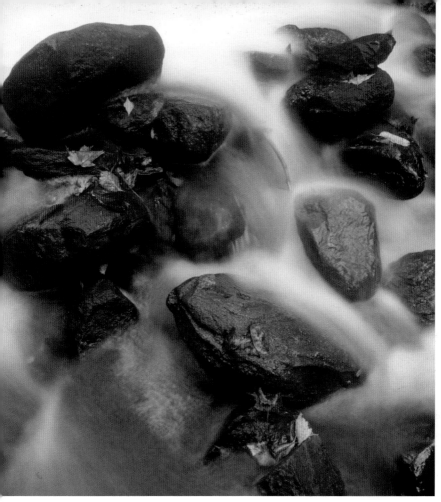

Croton-on-Hudson, New York

entering the lens, and therefore lets you shoot at a slower speed. Slow shutter speeds require a tripod for a sharp shot.

The unacceptable picture of this waterfall was taken at 1/125th second at f/2.8 with the ISO set at 800. No tripod was used. The much more pleasing photograph was taken at two seconds at f/22 with the ISO set at 100 (which offers minimal digital noise, as opposed to ISO 800, which has increased digital noise). For the second image, I used a tripod and neutral density filter. Both images were taken with my full-frame digital SLR and my 16–35 mm zoom lens set at 35 mm.

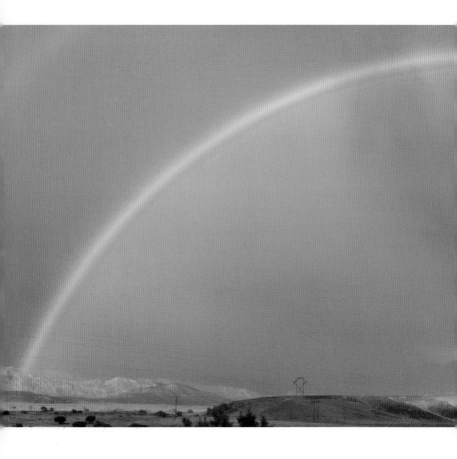

X Marks the Spot

"Being there" is one of the key ingredients for good travel pictures. Travel as much as you can and get inspired to take great pictures as often as possible. Remember that sometimes moving just a few feet to the left or right can make the difference between

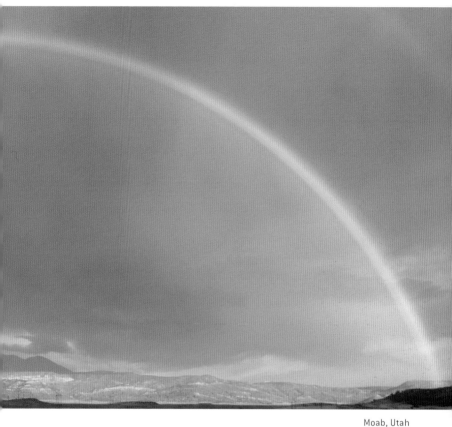

Moab, Utah

a great shot and a snapshot. When looking through your camera's viewfinder, think about the best possible spot from which to take the picture. For the double rainbow image, I framed the shot so that the brighter rainbow almost completely filled the frame.

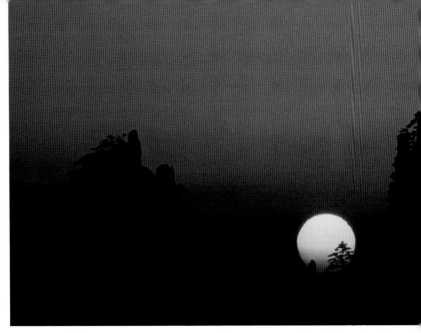

Danxia Mountain, China

You Snooze, You Lose

Simply put, get up early and stay out late when traveling. In the early morning and late afternoon hours you'll get deeper shades of red, yellow, and orange—what professional photographers often call the day's golden light. What's more, long shadows will add a sense of depth and dimension to your photographs. In contrast, pictures taken around midday will look cool and flat. If you really want to get a moody photograph, shoot an hour or so before the sun rises or after it sets. You'll need a tripod in order to use long shutter speeds, and a cable release for your shutter or your camera's self-timer to prevent camera shake. Long shutter speeds often result in an increase in digital noise (called *grain* in film pictures). Some cameras offer a noise reduction feature, which you manually activate. Noise reduction does work, but the noise reduction process increases the time it takes for a picture to be written to the camera's buffer, which can prevent you from taking another picture in rapid succession. Because you can reduce noise in the digital darkroom (using a noise reduction filter or a blur filter), I think it's best not to use the camera's noise reduction feature.

Bronx Zoo, New York City

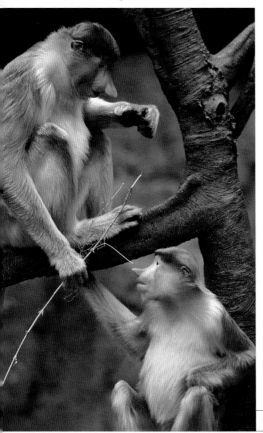

Zoos and Wildlife Parks

Practice wildlife photography skills at zoos and wildlife parks. When taking pictures, try to imagine what it would be like to shoot in the field. Get to know what your camera and lenses can do, so that when you do shoot wild animals, making camera adjustments becomes second nature. A telephoto lens helps isolate subjects from distracting background elements.

Recipe for Successful Photographs

When all the ingredients—sometimes magically, sometimes strategically—come together, we end up with a photograph that we like, which is what photography is all about. In this lesson I'll share with you my personal recipe for getting great shots.

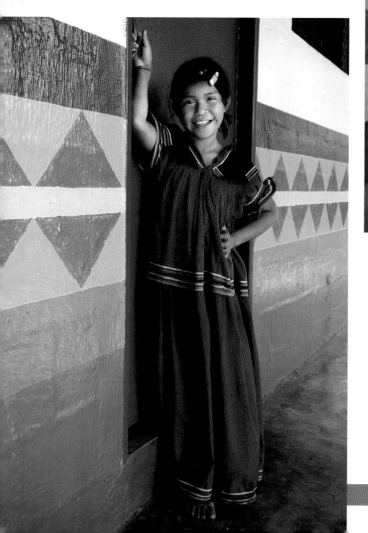

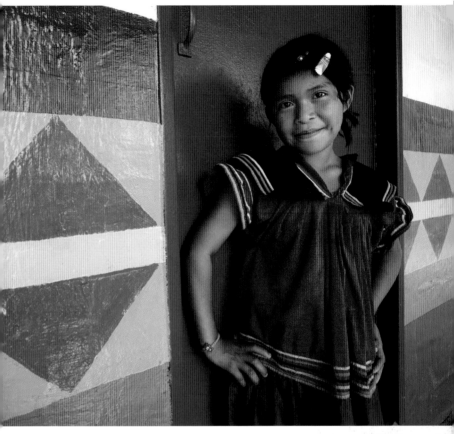

Panama

The picture of an Embera schoolgirl in Panama is one example of a recipe that worked. I think the picture is a success.

The picture on this page is okay, but I feel more connected to the subject in the first picture. I also like the shot's composition and the girl's expression better.

When you are thinking about a picture, think about all the ingredients you need to make it a success. My personal list follows.

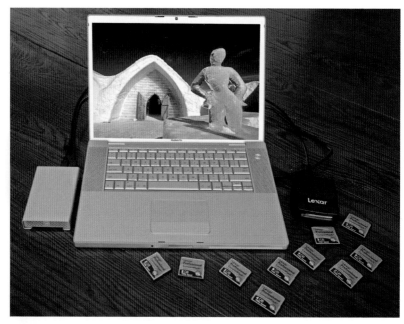

Hotel room, somewhere on Earth

Cameras, Lenses, Accessories, and Computers

It's important to choose the right camera, lenses, memory cards, and accessories to accurately record our own unique vision of a scene. Digital travel gear includes a camera (or two), laptop, backup hard drive, a memory card reader, and plenty of memory cards. When it comes to a computer, if you have a choice between more random access memory (RAM) or more storage capacity on the hard drive, go for the RAM. Digital image-editing programs run faster with more RAM, especially when other applications are open.

Choose Your Lenses Wisely

Lenses deserve special consideration. Because digital pictures can be enlarged by more than 200 percent on computer monitors, we can see flaws in image sharpness that we did not see when viewing smaller prints and slides.

Since flaws are more visible when an image is enlarged, particular care must be taken when choosing a lens, especially if you plan to make large prints.

Fixed focal lenses are generally sharper than zoom lenses. However, an expensive zoom lens may be sharper than an inexpensive fixed focal length lens. (Usually, we get what we pay for.) Soft pictures can also be sharpened somewhat in Photoshop, Aperture, and Lightroom.

Other lens features to consider are close-focusing distance, weight, and size. Close focusing is an advantage when working in tight quarters. Weight and size are important when traveling.

How does one find out which lenses are sharp and which are not, and which lens or lenses to choose? In the end, it's up to each individual photographer. One way is to try an Internet search for "sharp lenses." A host of Web sites offer lens reviews.

Of course, we can also go to the Web site for your camera to view a listing of all the lenses that are compatible with it.

For this picture of one of the bedrooms in the Ice Hotel in Quebec, I used a 14 mm lens for a super-wide view of this relatively small room.

Quebec City, Canada

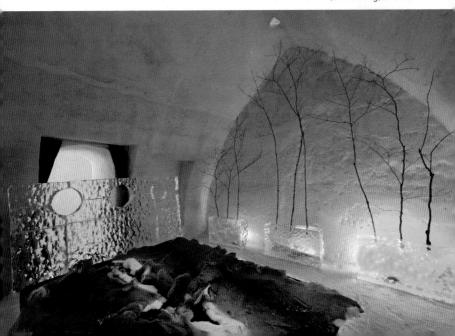

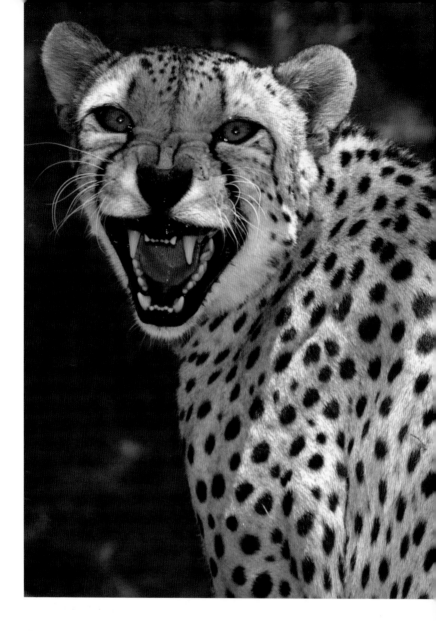

Select an Interesting Subject

Of utmost importance to a great photograph is an interesting subject. The subject is the reason why most of us travel to take pictures. I have traveled to Glen Rose, Texas, three times to photograph the exquisite animals there, including these cheetahs.

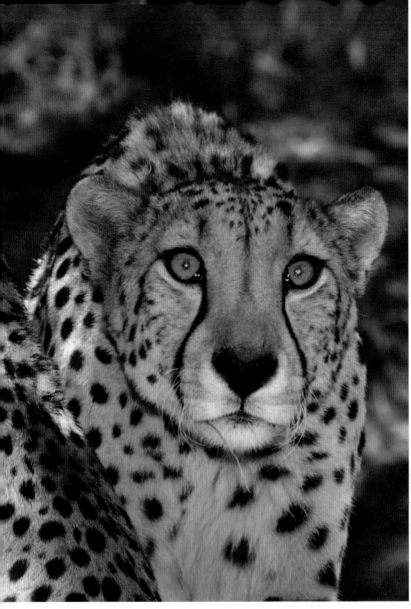

Fossil Rim Wildlife Center, Texas

When you find an interesting subject, it's a good idea to take your time. Walk around the subject to find the best possible angle, as well as the best lens to use.

Get Inspired

Of course, we need to be inspired to take good pictures, as I was at the Double JJ Ranch during this beautiful sunset. Inspiration gets us up extra early to photograph sunrises and keeps us out into the night to photograph sunsets. It compels us to approach strangers in strange lands with our cameras, hoping to capture an interesting face or activity. Inspiration draws us to sweeping landscapes and seascapes, to places where we can stop and smell the roses, recording our memories to be relived again and again through our photographs.

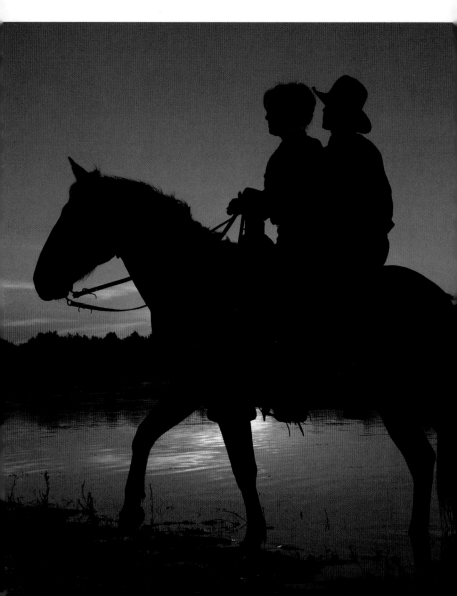

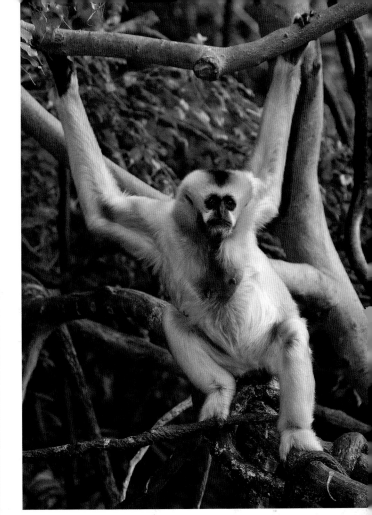

Bronx Zoo, New York City

Patience Pays

Oftentimes we need patience for a good picture. That may mean waiting hours for just the right light, for someone to walk into or out of a scene, until we get comfortable shooting in a location, or for our subject to get comfortable with us.

I waited for almost an hour for this gibbon at the Jungle World exhibit at the Bronx Zoo to be in the perfect position for a clear shot.

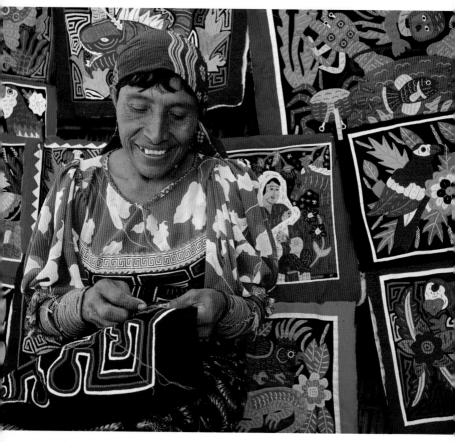

Kuna Yala, Panama

Attitude Affects Our Pictures

Pros know that attitude affects pictures. They keep this expression in mind: "The camera looks both ways—in picturing the subject, we are also picturing a part of ourselves." Another way to say this: All pictures are self-portraits.

When I was photographing this Kuna woman, I was honestly happy and positive. I think you can see that the woman was having as much fun during the photo sessions as I was having taking her picture.

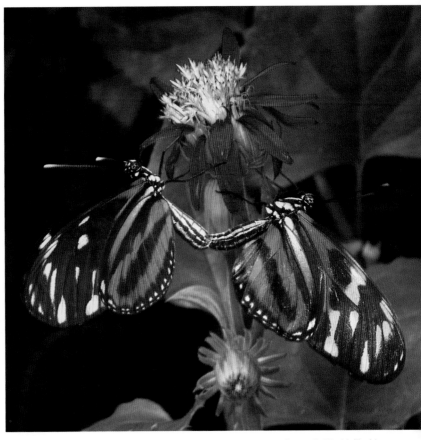

Butterfly World, Florida

Work Hard, Get Lucky

Luck is also an important ingredient, and I was darn lucky to see these Isabella butterflies mating at Butterfly World in Coconut Creek.

I've been very lucky when it comes to my travel photographs.

When it comes to good fortune, however, I can tell you this: the harder you work, the luckier you become. I work my butt off when I'm traveling, staying out all day and looking for photo opportunities everywhere.

So work hard! You'll be surprised at how lucky you become.

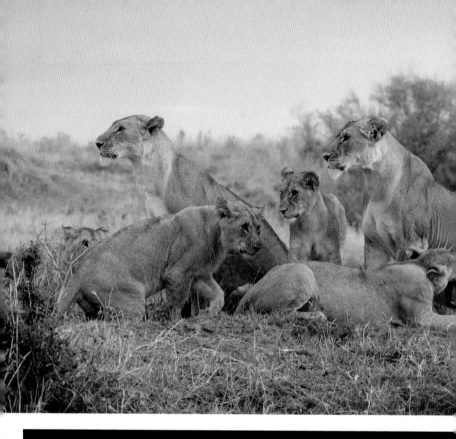
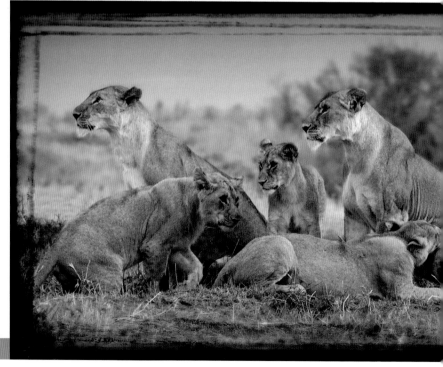

Kenya

Know Your Camera and Your Image-Editing Program

Knowing what your camera and image-editing program can and cannot do will help you make decisions that will lead to creative pictures. Knowing your camera helps make instant on-site decisions—about exposure, shutter speed, f-stop, and so on— easier. In the digital darkroom, there are endless possibilities. We have the tools at our fingertips, and it's up to us to craft our images to our own liking. My image (at bottom) of two lionesses and their cubs is the result of on-site know-how and a bit of digital darkroom work.

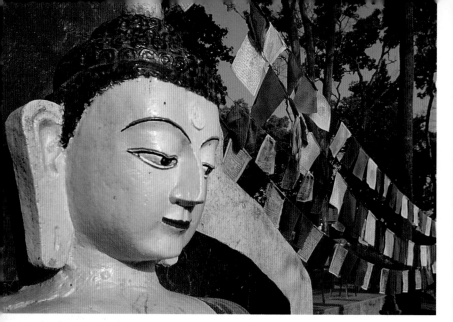

Nepal

Learn about Your Subject

Another requirement for successful photography is knowledge about the subject, be it a landscape, a person, an animal, or a place. The more you understand your subject, the better you'll be able to capture it. At a casual glance, this may look like a statue of Buddha with some flags in the background. But the flags are special. According to Buddhist belief, these "prayer flags" are inscribed with prayers that the wind carries to distant lands. Knowing this made taking the picture at Monkey Temple more meaningful for me.

Take *and* Make Pictures

Taking pictures means that we simply photograph what we see, as illustrated in the tighter shot. *Making* pictures means using our artistic eye to create a better composition that is more informative and interesting. In the closer of the two pictures, we see the woman with some thread, but we don't know what she is making. Before taking the wider photograph, I placed several of the bags that she and other women in her tribe had made on the wooden deck, filling the dead space in the scene with context.

Panama

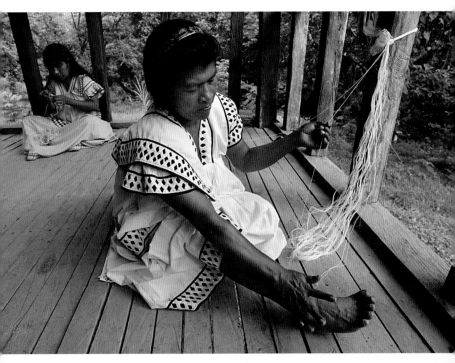

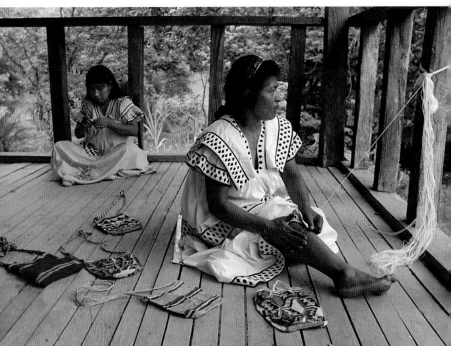

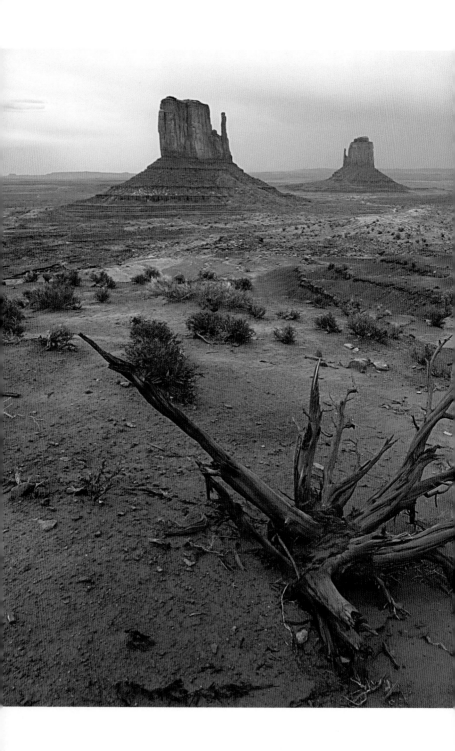

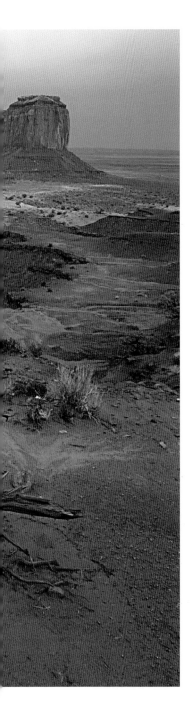

Be Positive When the Weather Turns Bad

Hey, as much as we'd like all our days to be filled with sunshine, it's sometimes going to be overcast or raining, or worse. The key is not to put your camera away when the sun retreats. Keep a positive attitude, protect your gear from the elements, get out there, and shoot! You may be surprised at the moody scenes you can capture. This picture is one of my favorites from Monument Valley. The subdued effect created by the overcast sky helps convey the feeling that the land is sacred to the Navajos who live there.

Monument Valley, Arizona

Travel Smarts

In my travels, I've gained a few "travel smarts"—usually the hard way, by making mistakes.

Getting sick, not having the right gear, displaying poor manners, wearing the wrong clothes . . . all can ruin any photographic adventure.

Kenya

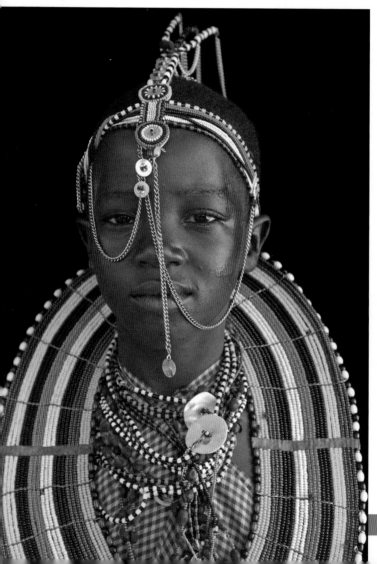

Learn from some of my mistakes, and realize that being prepared makes your venture more pleasant and more productive.

Calling on some travel smarts has helped me to come back with a high percentage of good pictures from fairly exotic locations, including Kenya.

They have also helped me when shooting in fairly difficult conditions closer to home, including the national parks in the American Southwest, where the temperature can climb to more than 100°F, which could cause dehydration in a relatively short period of time. Even when only going an hour away, I plan ahead: "Be prepared," as the Boy Scouts of America say.

Kenya

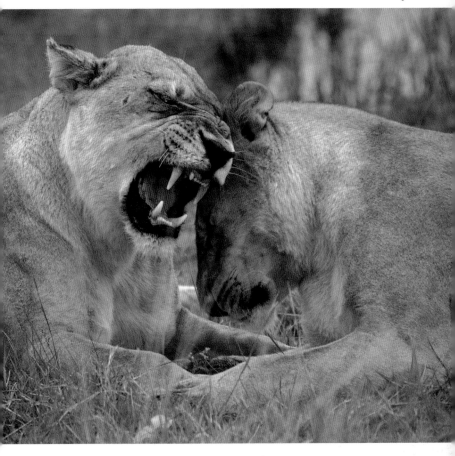

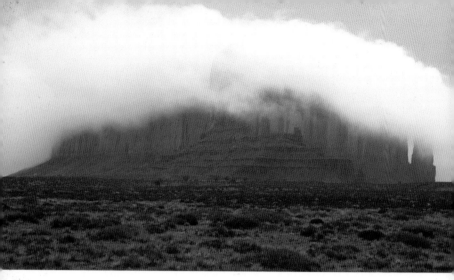

Monument Valley, Arizona

Be Flexible

Traveling is a great experience and a wonderful education. Visiting and photographing new places is invigorating. However, unexpected bad weather, airport delays, and other travel-related challenges can arise. When traveling, the key to maintaining a good attitude is to be flexible. Look at unexpected situations as opportunities, rather than as problems, and you will find it easier to maintain a positive attitude.

Choose Your Shoes

If you plan to take pictures in Buddhist temples, as I did in the Temple of the Reclining Buddha you'll want to wear sandals or shoes that slip on and off very easily, so that you don't have to lose time untying and tying shoelaces at each temple visit. I learned this tip from photographer Lou "Boston" Jones. Footwear is also important when shooting in the field or in the city. For example, if you're shooting in the rainforest, waterproof hiking boots help keep your feet dry and comfortable. When you are photographing in the mountains and canyons, hiking boots supply sure footing. If you plan to shoot in the water—at a lake or river or by the shore—consider fishermen's waders or scuba diver's booties.

Bangkok, Thailand

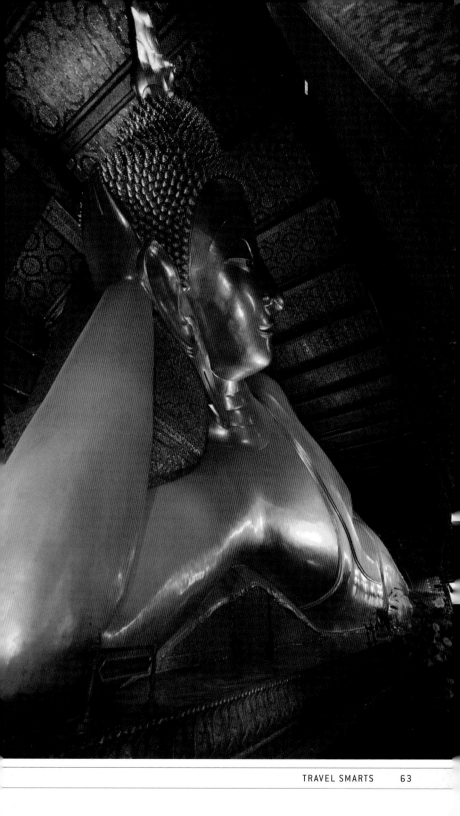

Watch What You Eat

Being careful about what you drink and eat may make the difference between feeling great and feeling really, really bad. Avoid the drinking water, and don't even brush your teeth with tap water when traveling in a foreign country. Don't have a salad, because the lettuce and tomatoes may have been washed in tap water. What's so bad about the tap water? Tap water elsewhere contains different kinds of bacteria and organisms than your body is used to. It's the bacteria that can make you sick. If you live in Mexico and come to New York, don't drink the water. Stock up on bottled water instead. It's also a good idea not to drink milk that has not been pasteurized, or eat dairy foods made with such milk. And remember to eat hot food hot. By the way, if you find yourself in San Miguel de Allende, I highly recommend having lunch and dinner in Ole! Ole!, pictured here. Great food, great price!

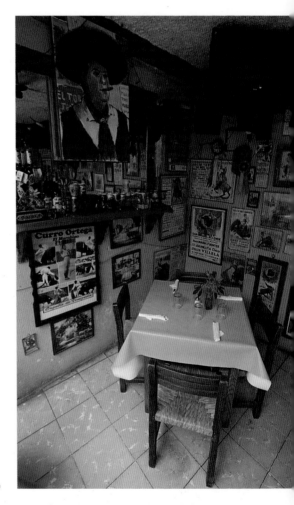

San Miguel de Allende, Mexico

Do It When You Can

My dad has a great philosophy: When traveling, eat when you have the opportunity. That's pretty good advice for on-the-go photographers. I actually ate some of this watermelon during a trip on the Celebrity cruise ship *Constellation*, which helped me to hydrate before going out into the hot and humid weather. My friend Pat Stevens adds to my dad's suggestion. She says, "Shop when you can."

Onboard the *Constellation*

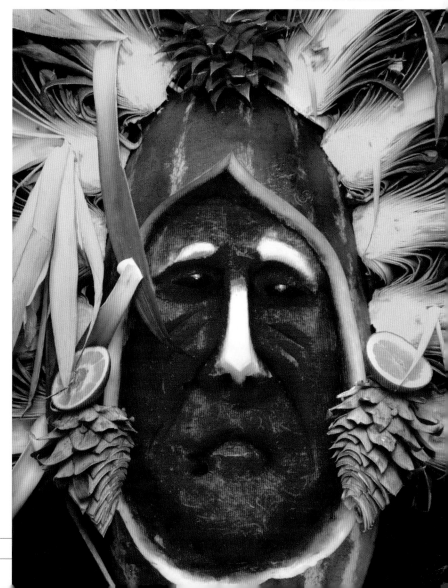

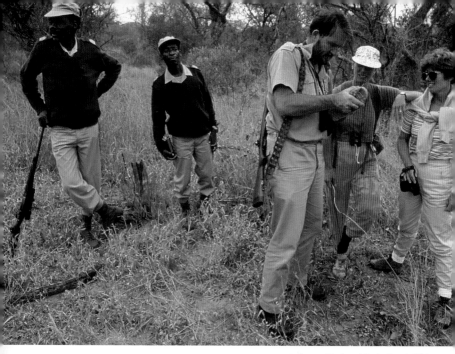

Exeter National Park, South Africa

Dress for Success

What's wrong with this picture? As I am sure you noticed, the woman in pink has not dressed for a photo safari, where green, tan, and brown colored clothes are recommend to provide some camouflage. What's more, the woman is wearing sneakers, which don't protect her feet from sharp thorns that can poke through the soles of soft shoes. (Our guide is trying to remove a thorn from her sneaker.) If you go on a safari, dress for success, and for protection from the animals *and* plants! Photo vests and jackets not only make us look like professional travel photographers, but they are practical. All those pockets are great for providing fast access to accessories, such as filters, memory cards, flash unit, and even lenses. In addition, photo vests and jackets can act as an extra carry-on bag, letting us take extra gear on a flight. Wide-brim hats are important too, shading the face, neck, and ears from bright sunlight that can cause sunburn. In my opinion, sunglasses are also a must.

Queretaro, Mexico

Follow the Music

Photo legend Burt Keppler gave me some good advice before I took off for a trip to Bali: "Follow the music." When driving around a country, listen for music coming from local celebrations. We did, and found a celebration for the full moon. I also followed the music during a Mexican trip, and found a once-a-year celebration featuring local students dressed in traditional costumes.

Botswana

Get a Good Guide

Guides and translators are most helpful when traveling in foreign countries. Not only can they save you time in searching for a particular photograph, but they may also be able to help you see places and people you normally would not have had the opportunity to see. If you don't arrange a guide through a travel agent, you can usually get one through

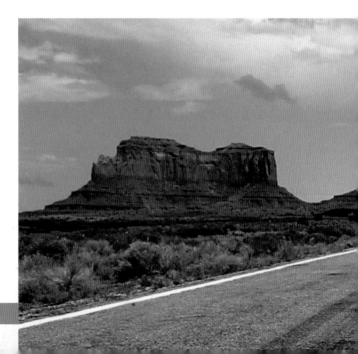

your lodge or hotel. I know for sure that I would not have seen or photographed as many animals as I did in Botswana if it had not been for my expert guides, who spotted this lion resting in the shade from a distance of about 300 yards while we were driving over a bumpy road. In spite of their great worth, good guides are often the least expensive part of a trip.

Keep On Searching

Perhaps the best source of information for travelers is the World Wide Web. Well in advance of leaving home, do an Internet search on your destination. Check for weather, sites, photo restrictions, religions, special events, festivals, holidays, local currency, local power supply, and so on. The more you know about a destination, the better prepared you'll be to photograph it. If you plan a driving trip in the United States, join the American Automobile Association (AAA), which offers detailed maps and other useful information for road warriors. AAA TripTiks were very helpful for me when I was driving throughout the American Southwest. For international travel, I rely on the Lonely Planet guides (www.lonelyplanet.com). They contain honest and practical advice on destinations.

Monument Valley, Arizona

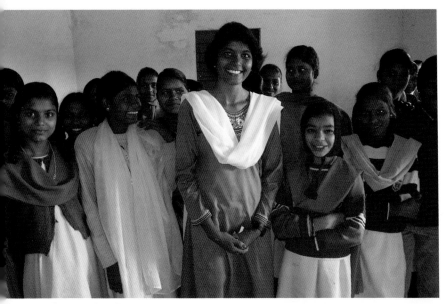

Khajuraho, India

Make a Donation If Possible

When I travel, I often pay adults a small amount, maybe a dollar or five, in exchange for taking their pictures. I feel that if I'm getting something out of the photo session, so should the subject. However, when photographing a child or a group of children, I try to find out if I can make a donation to a local school or charity. That's what I did when I was photographing in India.

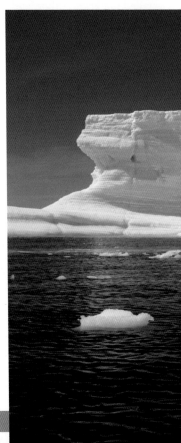

Salt and Water

Digital cameras don't like water, especially salt water. When shooting in potentially wet conditions, as I did during my Antarctica adventure, I used a plastic cover to protect my camera from the elements. If you plan to shoot in wet conditions, don't leave home without protection for your camera. See "Gear for Travelers" for more information.

Off the coast of Antarctica

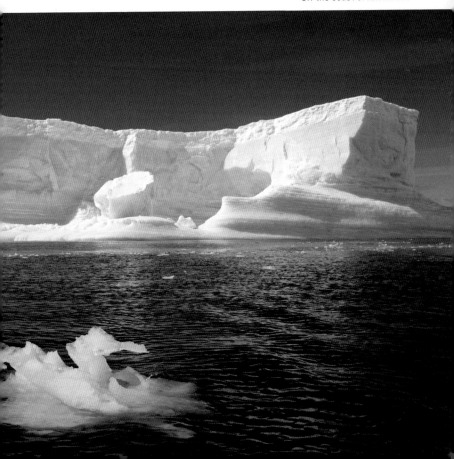

Sign 'Em Up

A signed model release is required if you plan to use a
photograph of a person for commercial purposes. The release
has to say that the person gives you the right to use the picture
for advertising or other commercial purposes. It should include
the date, signature, and printed name of the person
photographed. You may also need a release for a building if you
plan to use the picture commercially. I lost a photo sale because I
did not have a release for an art deco building in Miami's South
Beach. Even though I am friends with model Chandler Strange, I
still get her to sign a release.

Shooting above Sea Level

When I was in Utah, I was about 8,000 feet above sea level, where the air is much thinner than it is at my home in New York, which is just about at sea level. A short hike into the canyon took my breath away, and I'm in fairly good shape.

 When traveling, shooting, and hiking at high altitudes, take it easy. Take rests and don't push yourself. If you are very serious about getting good pictures at high altitudes, arrive a couple of days early and acclimate to the thin air, especially if you will be hiking with a backpack filled with camera gear. One baby aspirin a day helps prevent altitude headaches for some people.

Bryce Canyon, Utah

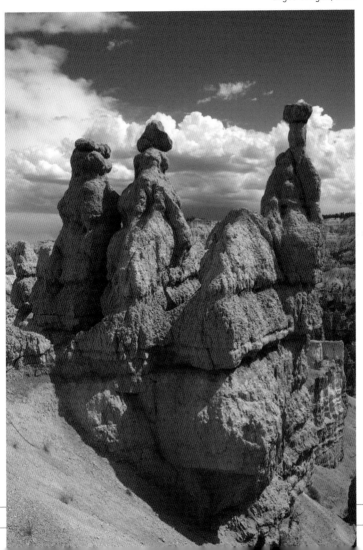

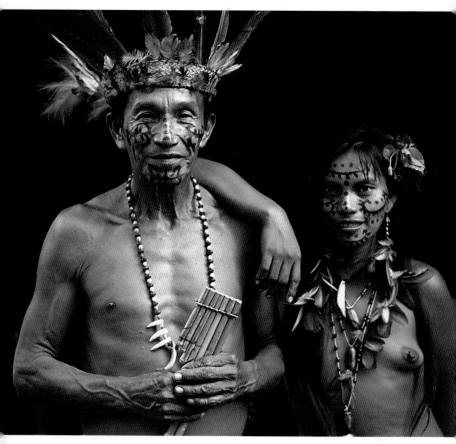

Amazonas, Brazil

Stay Healthy

A visit to your doctor before a trip can help you stay healthy when traveling. He or she can recommend medicines and remedies for traveling to exotic locations. You can also search for information about your destination on the Web site for the Centers for Disease Control (www.cdc.gov). This will give you an idea of what potential health problems you may run into, such as malaria deep within the rainforest.

Take Notes

When traveling, take notes to help you remember facts about your pictures that you might like to share later. I used my camera's voice recording capabilities while visiting several different parks in Alaska, and had I not done so when photographing the 14 totem poles at Totem Bight State Historical Park in Ketchikan, I probably would have forgotten its name. Accurate facts make a story more entertaining. Speaking of records, if you plan to write off any of your trip (if you are or plan to be a professional travel photographer), you'll need to keep all receipts for Uncle Sam.

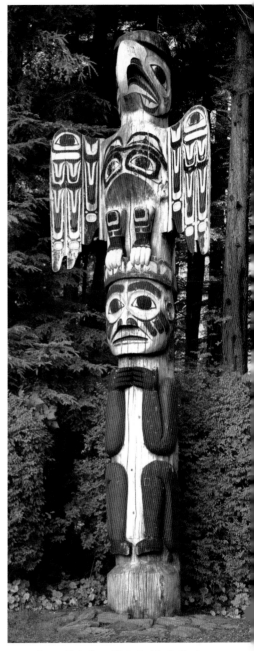

Totem Bight State Historical Park, Alaska

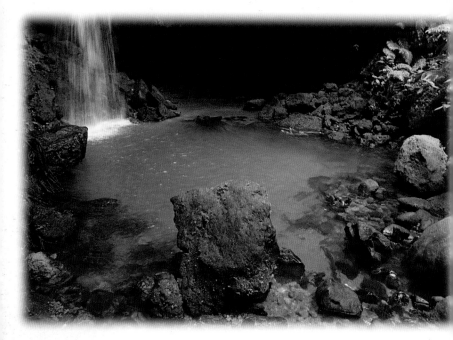

Emerald Pool, Dominica

Tourist or Traveler?

My guess is that you are a traveler, not a tourist. Tourists follow the group. Travelers find their own opportunities. If you have the option, get out on your own and find unusual photo ops. With a group, you'll probably get the same old shots, riding from site to site in a bus. What's worse, you'll spend a portion of the tour at predetermined shopping stops. You'll quickly learn why a tour is called a sightseeing tour and not a photography tour. That being said, traveling with a group in a foreign country does offer a feeling of comfort. Doing so for a day can give you a good overview of the location and ideas for subsequent visits. These two pictures illustrate the difference between traveling with a group and traveling alone. To get the more intimate shot, I had to go back the next day, before the pool was officially open (my guide knew a secret path), because this is one of the most crowded places on the island. I added the vignette to the more creative photograph in Adobe Photoshop for an artistic touch.

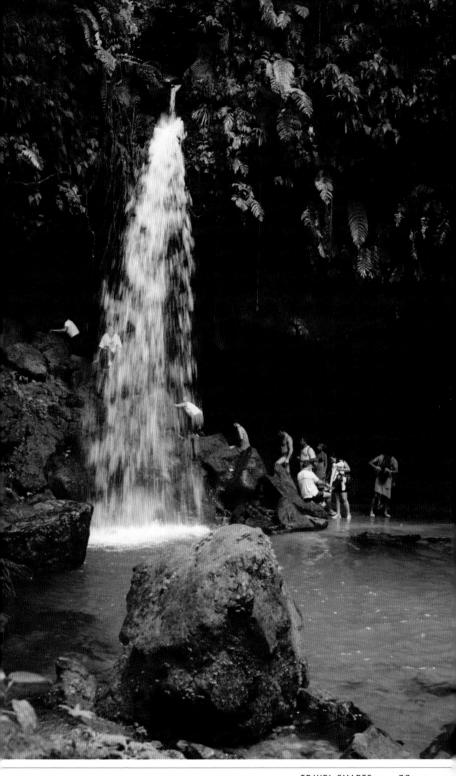

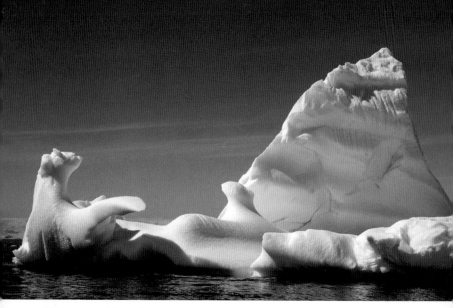

Off the coast of Antarctica

Shoot on the Move

Sometimes group travel is the only
way to see a site. If this is the case, try
to sit next to the driver, so that you can
shoot out the open passenger window
while moving. Better yet, ask the
driver to slow down so that you can
take a picture. You may want to
practice "on-the-move" techniques at
home—have a friend drive you
around—which is how I got good at
shooting on the move.

My at-home practice sessions
helped me capture this iceberg
picture, taken while I was riding
in a Zodiac.

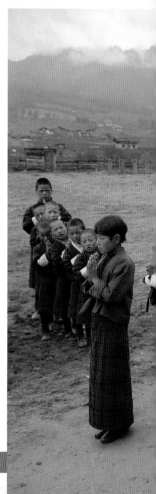

Wake Early

When some people see a photograph of mine that
they like, they say that I'm lucky to get to do what I
do. Wake up early on your travels and you might
get lucky, too, as I did when I got up at five o'clock
in the morning to get to this school in Nepal just as
it opened at eight.

Nepal

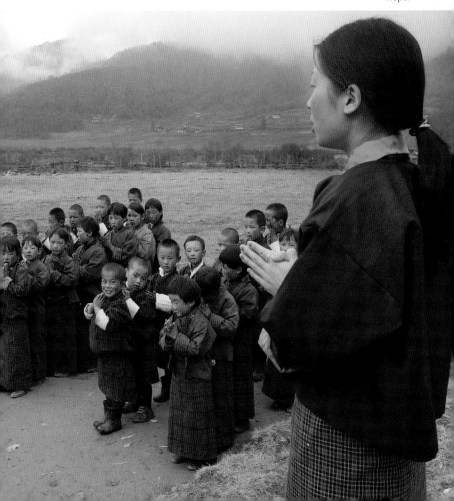

LESSON 5
See the Light

Seeing the light is a key ingredient to getting a good exposure. If we learn how to see the light—the highlights and shadows in a scene, the contrast and color, the direction of light, the subject's brightness and the background's brightness, and even the movement of light—we will make better exposure decisions and become better photographers.

This field guide does not have room for a detailed discussion about seeing and recording light. Here I share the basics of what's involved.

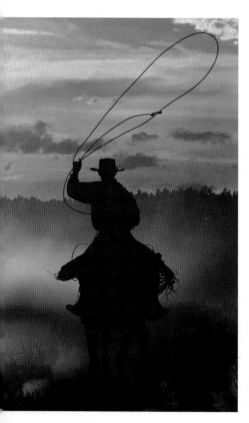
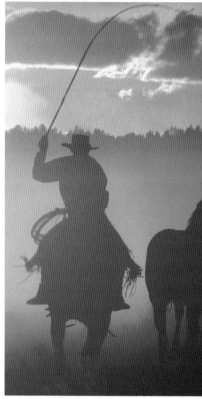

I'll illustrate my tips using pictures that I took on the Ponderosa Ranch in Oregon during one of my photography workshops. The images on these pages are two of my favorites, both taken at sunset. When shooting at sunset, I usually underexpose my pictures by one f-stop. That helps to avoid overexposed areas of the scene, enhancing the colors.

So let's take a look at seeing the light.

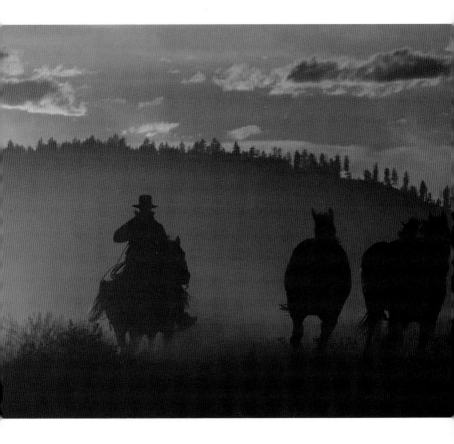

Soft Light Equals Easy Exposures

Unlike the opening pictures for this lesson, there are no strong highlights or shadows in this picture. The light is soft, making for a relatively easy automatic exposure. This is the easiest type of light in which to work.

In situations like this, you usually don't have to choose any exposure compensation. I like photographing when the light is soft, created by an overcast sky, shade, or diffused natural lighting or flash.

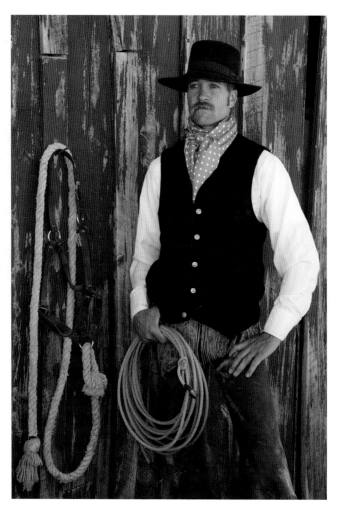

Front Lighting

Front lighting is nice for portraits, because you want the subject's face evenly illuminated. That was the case when I photographed these two horses running at sunrise. This is another easy automatic exposure.

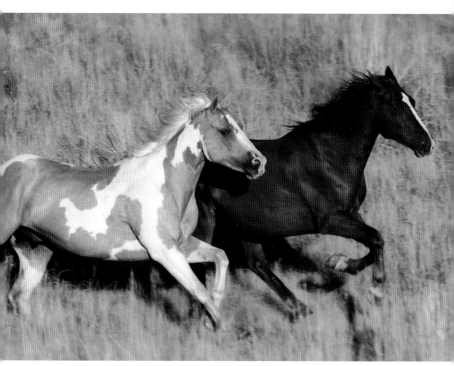

All images in this lesson were taken at Ponderosa Ranch, Oregon.

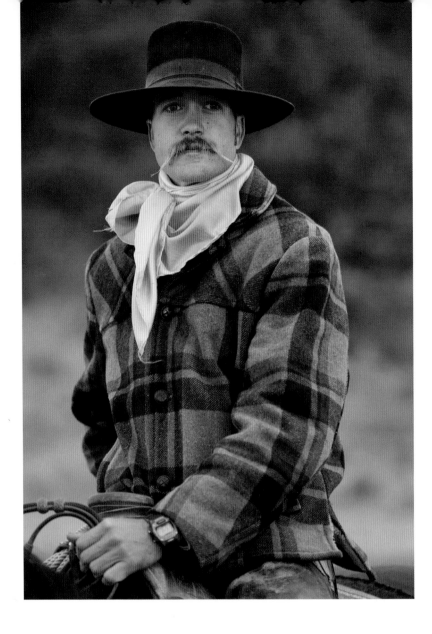

Overcast Lighting

Overcast days are perfect for shooting portraits of animals or people, because harsh shadows are eliminated by clouds. The soft light makes for somewhat soft images. Once again, auto exposure should do the job.

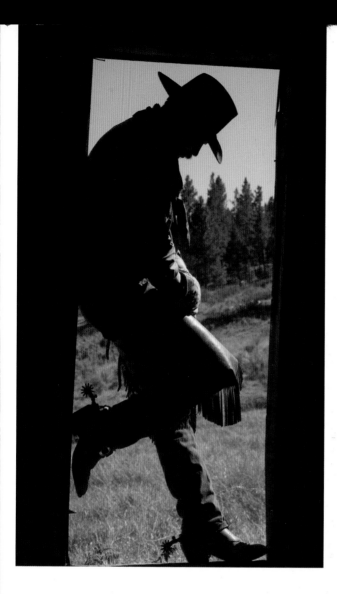

Backlighting

Backlighting creates dramatic silhouettes, as illustrated by this cowboy's picture. And speaking of backlighting, here's a photography joke: Someone asks a pro, "What is your day rate?" He replies, "$5,000, but it is $7,500 if I have to shoot into the sun." It's harder to shoot into the sun than away from it.

For a more dramatic silhouette, use your exposure compensation feature and set the exposure to –1.

Strong Side Lighting

Strong side lighting can be nice, but be careful about shadows. Sometimes, shadows can ruin a picture by obscuring a subject's face. At other times, shadows can enhance a scene, like the shadow of the cowboy standing off-camera in this photograph.

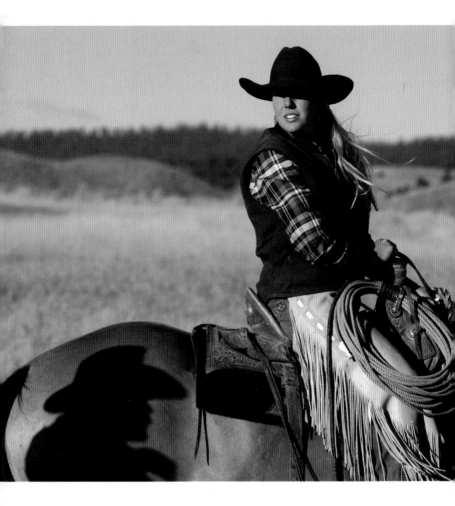

Strong Top Lighting

Strong top lighting is the worst type of lighting, especially when you are photographing people, because it obscures the eyes by casting harsh shadows into the eye sockets. And when a subject is wearing a hat, you can't even tell who is in the picture. If you don't have a flash or a reflector, avoid shooting at high noon, when top lighting is the strongest.

Warm Light vs. Cool Light

In addition to seeing the brightness level of a subject and the direction of light, we need to see the color of light.

Pictures taken in late afternoon and early morning, such as this reflection photograph, have warm tones: deep shades of red, orange, and yellow. Pictures taken around midday, such as the horse and rider picture, look cool, with a blue tint.

Seeing the color of light can help us make exposure decisions. It can also help us make white balance decisions, in our cameras, in Photoshop, or in Adobe Camera RAW—all of which lets us change the color of light by changing the white balance.

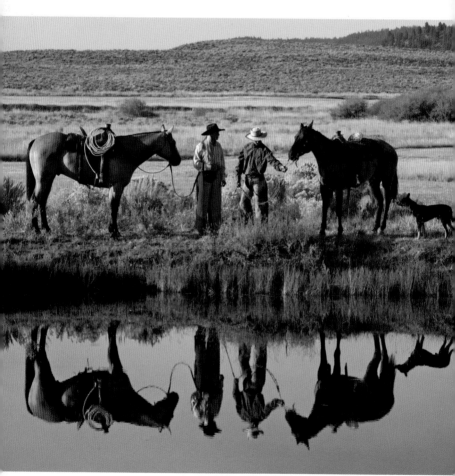

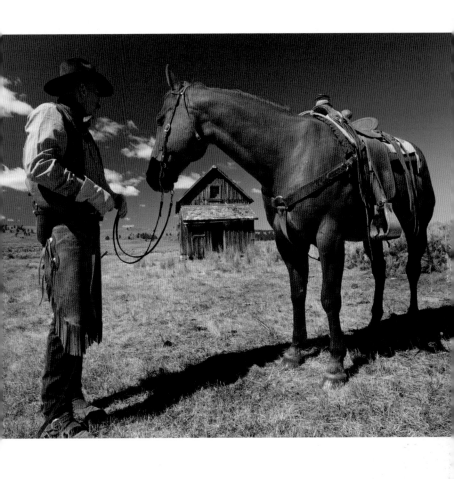

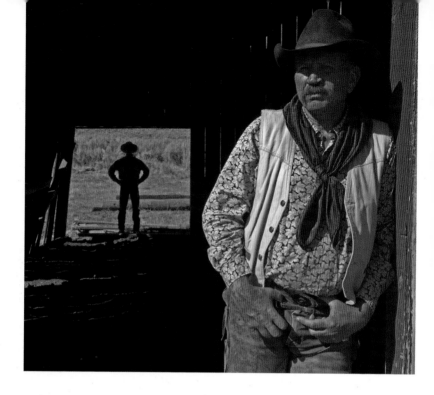

Expose for the Highlights

To record strong shadows without washing out the highlights, you need to set your exposure for the brightest areas of the scene (in this case, the cowboy in the foreground). To set the exposure for the highlights, use your camera's exposure lock, recompose your picture, and shoot. Or move in close to the subject, take a meter reading, set your camera to that f-stop and shutter speed combination, move back into position, and shoot.

Seek Out the Light . . . and Pictures

Okay, we've covered seeing the light. Now I want to remind you to seek out unique pictures. That's one of my number-one photography tips!

I like the lighting in this picture, but I also like the unique angle.

When you are out there taking pictures, ask yourself, "What kind of picture can I take that most people would not?" Your answers may pleasantly surprise you.

LESSON 6
Picturing People

Let me begin this lesson with a few words about an approach to taking people pictures. Basically, we can shoot what we see or we can pose a picture. We can take or make a picture.

The picture of Buddhist monks dashing out of temple to have lunch is an example of the former. I simply raised my camera and snapped the shutter.

When I *make* a picture, I find a subject and then position him or her in a setting, or I find a setting and

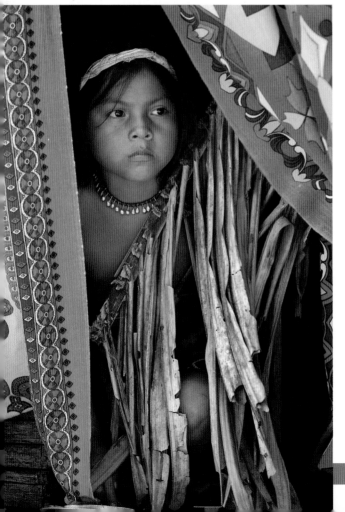

Panama

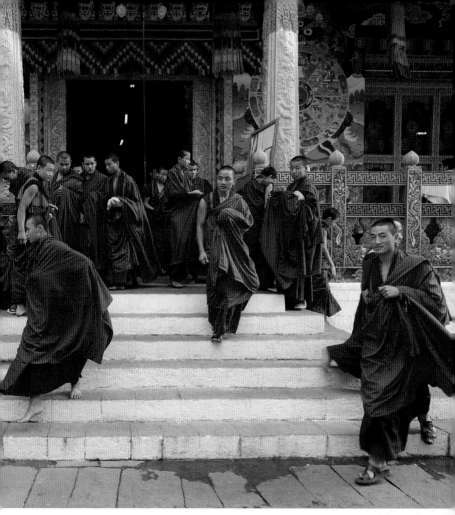

Bhutan

move the subject into position. In an Embera village in Panama, I saw an opening draped with colorful material in one of the huts. A perfect place to position a subject, I thought. So I found a cute little girl and, with her mother's permission, moved her into position and started my photo session.

The difference between taking and making a picture is one of the most important things to remember when photographing a person. But I have more tips, read on!

I use two lenses for my people pictures: a Canon 70–200 mm f/4 lens for portraits (as shown on the left) and a Canon 17–40 mm for my environmental portraits (as shown above). I use my full-frame image sensor camera, Canon 1Ds Mark III, to maintain the lenses' effective focal length.

Lens Basics

One of the most important decisions you need to make when photographing a person is which lens to use.

When you want to isolate the subject by putting the background out of focus, you generally want to use a telephoto lens (100 mm or longer) and shoot at a wide f-stop (f/2.8 to f/4). For this picture of an archer, I set my 70–200 mm lens at 200 mm and used an aperture of f/2.8.

When you want to have the background and the subject in focus, you generally want to use a wide-angle lens (35 mm or shorter) and shoot at a small f-stop (f/8 or smaller). For this picture of a young monk, I set my 16–35 mm lens at 20 mm and used an aperture of f/11.

Bhutan

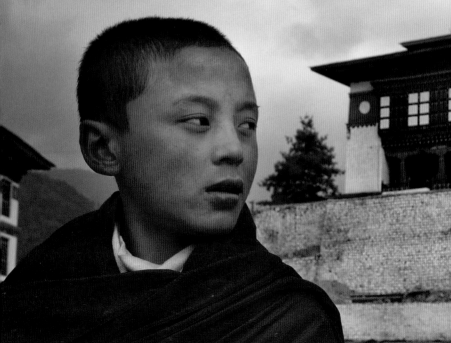

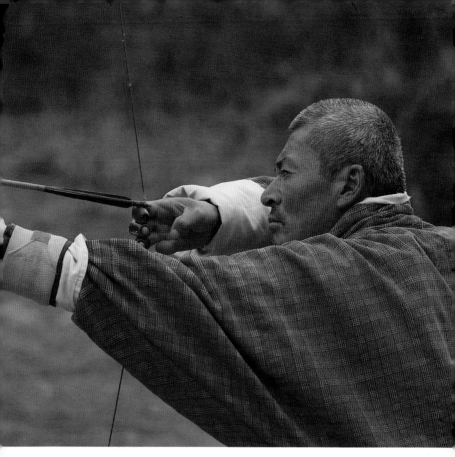

Get to Know Your Subject

Learning about the people you photograph will make your pictures more interesting. I am sure you have seen pictures of Indians in the Brazilian rainforest with their faces painted, but do you know *why* they paint their faces? They believe that face painting helps the gods and spirits of the rainforest recognize and protect them from harm. I learned this interesting fact from a local guide, who was invaluable in getting me into the village to photograph the tribe.

Amazonas, Brazil

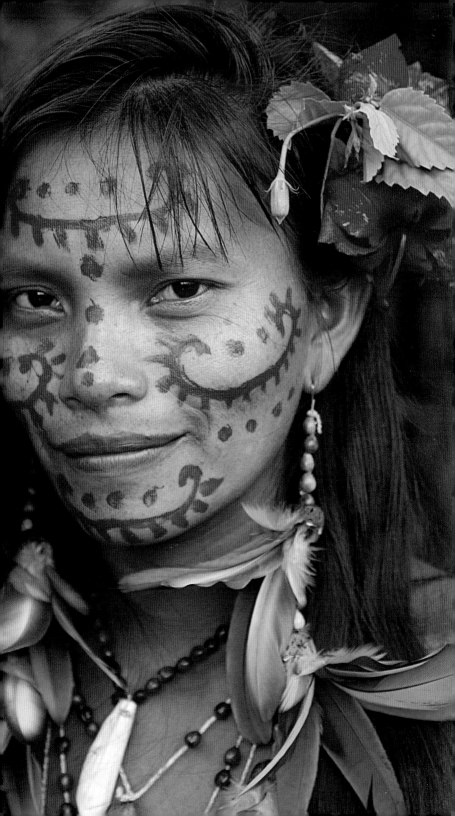

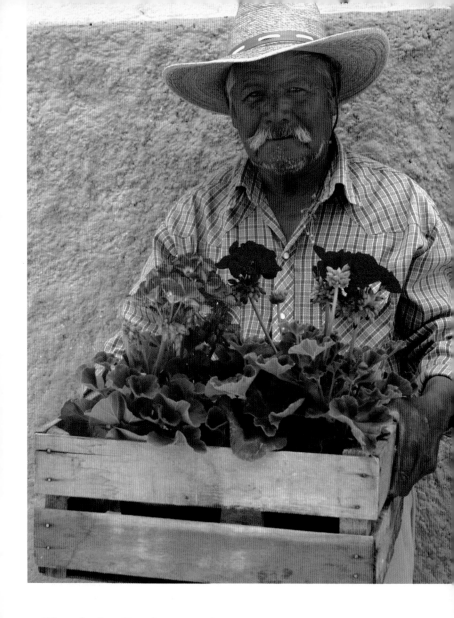

Watch the Background

Our eyes are incredible light receptors. They can see a much wider brightness range than any digital sensor (or film). That wide brightness range is one reason that people are disappointed with their pictures. The camera simply cannot capture the range of shadows and highlights that they saw when they took their picture.

San Miguel de Allende, Mexico

Here is one example to illustrate that point. I photographed this man selling flowers. My camera was set in the Program mode.

To my eyes, the man's face had the same brightness value in both scenes: I could see his face clearly. However, in the picture of the man standing by the white wall, his face is darker than in the picture of him

standing by the orange wall. What happened in-camera? The white wall "fooled" the camera's exposure meter into thinking that the scene was brighter than it is, and therefore underexposed the man's face, which only takes up a small portion of the frame. One way to compensate for this underexposure in the Program mode is to increase your exposure to +1 by using the camera's +/– exposure compensation control. Another way would be to use the camera's spot meter and set the spot (metering zone) on the subject's face. Another way would be to use a flash, which we'll get into in a bit.

When composing a portrait, look for light, and watch how the background can affect the exposure. Here one cowboy sat in direct sun with blue sky as background, while the other stood in the shade with a dark barn interior behind him.

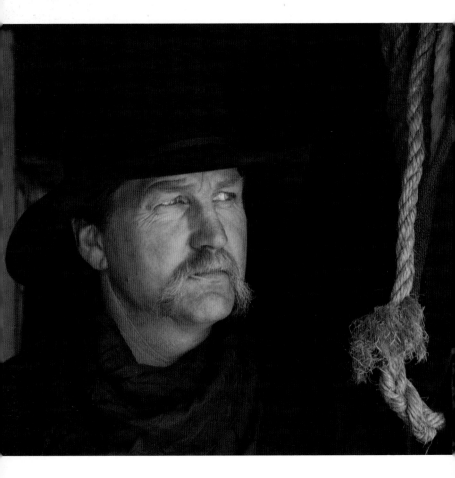

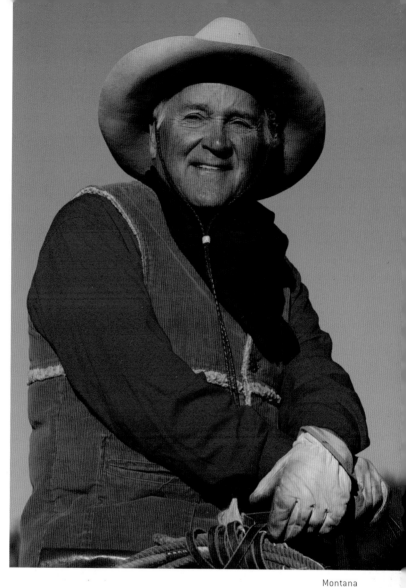

Montana

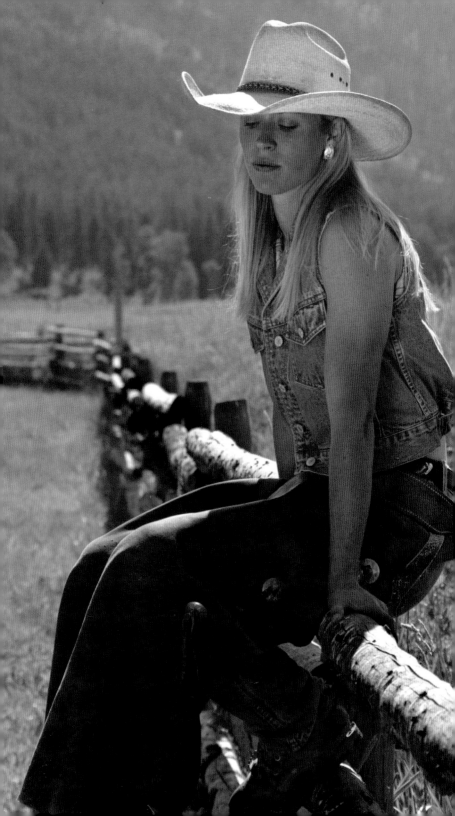

Control Light

In direct light, we can use a reflector, diffuser, or flash to fill in shadows if the subject is top- or backlit. In this situation, an assistant is holding a reflector to bounce sunlight onto the subject's face.

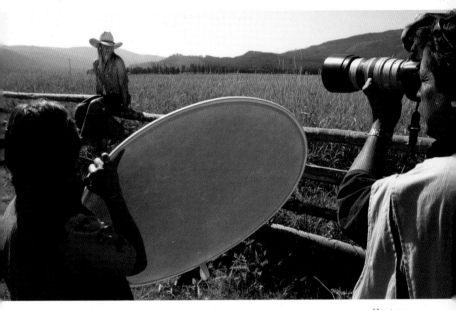

_ Montana

Bounce Light into the Shade

Here is another example of how using a reflector can enhance a portrait. No reflector was used for the dull shot of the cowgirl, who was standing in the shade. Notice how her hat is lost in the background. Look at what happened when a gold reflector, held in the bright sunlight, was used to bounce sunlight onto her face. It's much brighter and warmer. What's more, we can see her hat more clearly.

When using a reflector, keep in mind that bright, reflected light can cause the subject to squint, even hurt his or her eyes. To reduce this effect, begin the photo session by working several feet away from the subject (so the light is less harsh) and then move in closer.

Montana

Diffuse the Light

A diffuser looks like a reflector, but is translucent. This pair of photographs dramatically illustrates how holding a diffuser above

the subject can make a big difference. Notice how the harsh shadows created by direct sunlight are completely eliminated.

Croton-on-Hudson, New York

Using Daylight Fill-in Flash

Compare these two pictures. One has more pop than the other; it has more contrast. The catch-light makes the girl's eyes sparkle. Yet the brighter picture does not look like a flash picture, which is the goal in daylight fill-in flash photography. Here's how to reach that goal.

1. First, get a flash with variable flash output control, that is, +/– exposure control.
2. Turn off the flash.
3. In the Manual mode, set the exposure.

4. Turn on your flash and make an exposure with the flash set at −1 1/3. If your picture looks too much like a flash shot, reduce the flash output to −1 1/2. If it's still too flashy, continue to reduce the flash until you are pleased with the results.

This technique works because even in the Manual mode, the flash will operate in the Automatic mode. Master this technique. It is an essential tool used by most of my nature and travel photographer colleagues.

Queretaro, Mexico

More on Daylight Fill-in Flash

The aforementioned fill-in flash technique is especially useful when a subject is backlit, which in most situations causes a subject to be underexposed. Here are before and after examples that show the effectiveness of daylight fill-in flash photography.

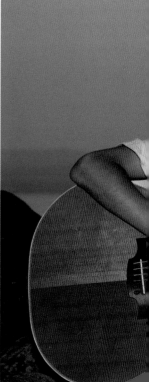

Croton-on-Hudson, New York

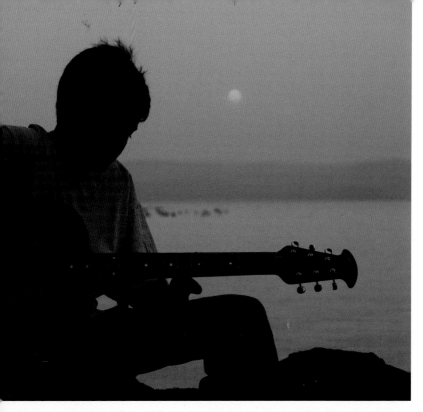

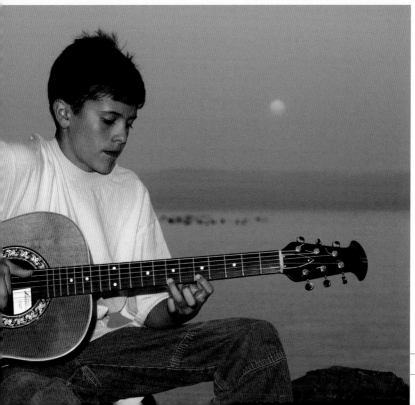

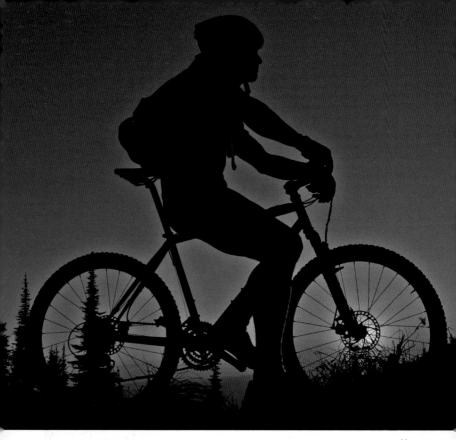

Montana

Shooting a Silhouette

In the picture of a mountain biker, which I shot on a mountaintop, we can see the subject's profile, as well as the strong silhouette of his bike.

To achieve this composition, I first knelt very low to the ground and placed the sun directly behind the hub of the front wheel, directing the subject to hold his head so that I could see his profile. Then I underexposed the camera's suggested automatic reading by one stop (for more vivid colors), producing a dramatic photograph in which friends of the subject could recognize him. In this example, I think using the daylight fill-in flash technique would have destroyed the mood of the breathtaking setting.

Remember, daylight fill-in flash is a great technique to use on people pictures. But when you are shooting a silhouette, go natural.

Create a Sense of Disequilibrium

Here's a technique that adds an extra sense of interest to a portrait: create a sense of disequilibrium. Simply tilt your camera down to the left or right and then take the picture. The off-balance feeling draws extra attention to the subject. This technique is not effective in landscape photography.

Barbados

Kuna Yala, Panama

Picturing People in a Scene

Compare these two pictures. I am sure you'll agree that the picture without the person is boring. The picture with the Kuna woman is much more interesting. Whenever possible, try to include a person in the scene.

Compose in Thirds

This is not only a very basic technique, but also a solid one. When possible, compose in thirds, that is, imagine a tic-tac-toe grid over a scene and place the main subject where the lines intersect. This composition technique causes the eye to wander around the frame and to look for other objects in the picture. I photographed this woman at a prayer wheel.

Timpu, Bhutan

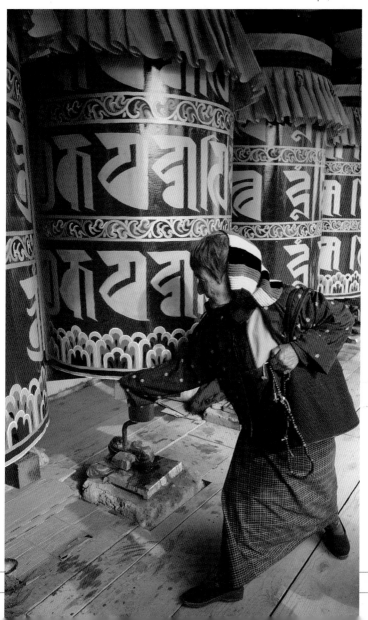

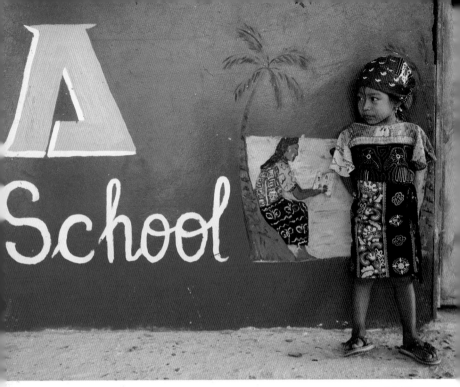

Kuna Yala, Panama

Looking Away

Subjects don't always have to look at the camera or be aware that you are photographing them. I photographed this little Kuna girl with my 70–200 mm lens set at 200 mm. Because I was positioned a good distance from the subject, and because I shot fast, she was unaware that I was photographing her. Afterward, I asked her mother if it was okay to use her picture in my books and magazine articles. She said yes.

Respect Your Subject

One of the most important aspects of photographing a person is to respect him. Young or old, close to home or far away, if we respect our subject, he will be inclined to return that respect. I photographed this holy man at a Choten. I think he knew that I respected him, which is why, I feel, he let me take his picture.

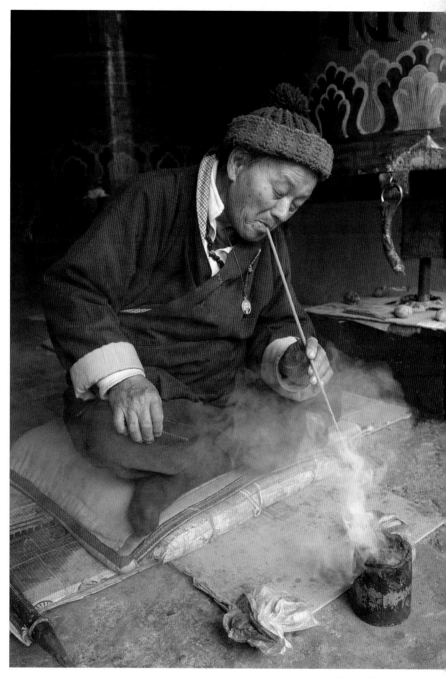

Timpu, Bhutan

Watch for Lens Flare

Compare these two photographs of a "sheriff." One looks crisp; the other looks dull. The reason? Direct light falling on the front element of the lens caused *lens flare*, which reduces contrast and makes a picture look dull. To avoid lens flare, use a lens hood, or shade the front of the lens with your hand or a hat.

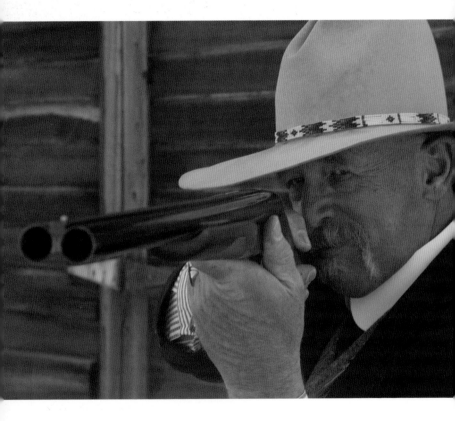

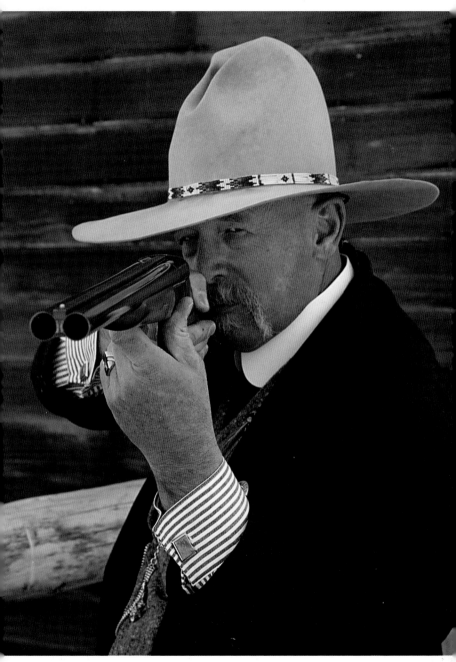

Nevada City, Montana

Shooting Action Sequences

When it comes to action photography, taking lots of pictures is the name of the game. Set your camera on rapid frame advance and start shooting before the peak of the action. That way you'll be able to get a picture with impact. If your camera has a bit of shutter lag (a delay between the time you press the shutter and the time the picture is actually taken), press the shutter a few seconds in advance of the start of the action.

Also keep in mind the number of pictures the camera's buffer can handle before it locks up and writes a sequence to the memory card. If you can only shoot three to six pictures before your camera locks up, you'll want to time your shots accordingly.

Another factor to consider is the writing speed of a memory card. Some cards offer a fast writing speed and let you keep on shooting (if your camera offers a fast writing speed). Mid-range to high-end digital SLRs usually offer a fast writing speed. Low-end digital point-and-shoot cameras usually do not let the camera write as quickly.

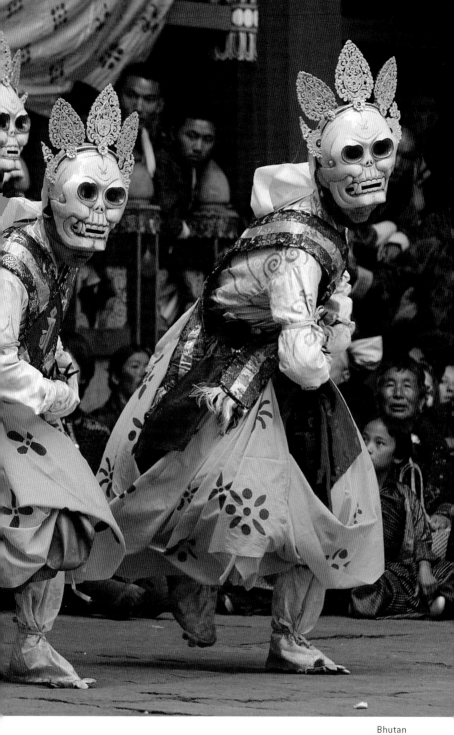

Bhutan

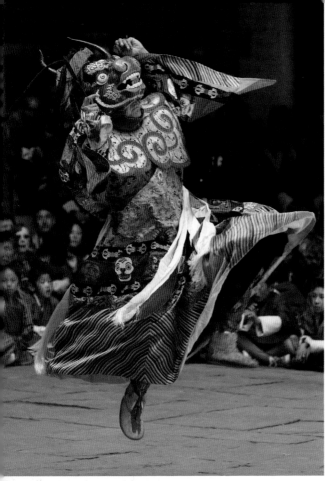

Bhutan

Freeze the Action

When photographing sports action, we can either freeze or blur the action. Freezing the action is fairly easy. Select a shutter speed of 1/500th of a second or higher. I used a shutter speed of 1/1000th of a second for this photograph of a dancer at festival in Bhutan.

Blur the Action

To blur the action, which can create a greater sense of speed, we need to shoot at slower shutter speeds, but the shutter speed depends on how fast the subject is moving, the direction in which the subject is moving, and the effect we want to create. We need to experiment with different shutter speeds to achieve a successful blur.

For this picture of my friend Wally (who was 72 years old when the picture was taken!), I used a shutter speed of 1/30th of a second. You will notice the background is blurred. I also used a technique called *panning*: I moved the camera to track Wally and his horse. Panning kept Wally relatively sharp, but blurred everything else.

Here is the panning technique: Select a slow shutter speed (between 1/60th and 1/15th of a second), start to follow the action of the subject moving horizontally in front of you, take the picture when the subject is directly in front of you, and then keep following the action for several seconds. It may take several exposures to get the desired results.

Panning is a hit-or-miss technique. To get this successful pan I failed several times, moving the camera too slow or too fast. We can digitally create the panning effect, with a 100-percent success rate, in the digital darkroom. I cover that technique in my book *Rick Sammon's Complete Guide to Digital Photography 2.0*.

Montana

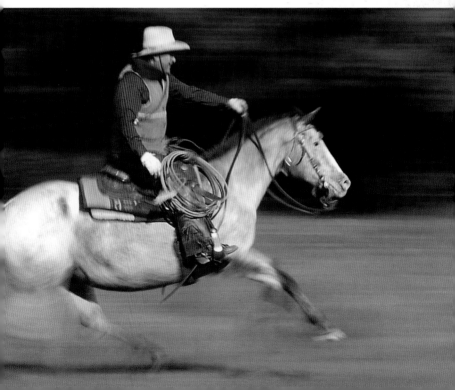

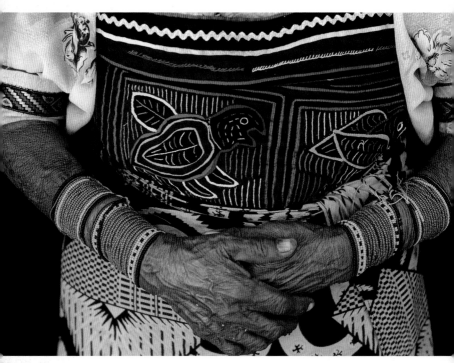

Look for Details

Oftentimes we get so focused on a face or the action or the surrounding environment that we overlook subtle details of a person's appearance, such as this Kuna woman's hands and the spur on this cowboy's boot.

Looking for and photographing details is fun, and it also helps to tell a story about the subject.

Marrow Bone Springs, Texas

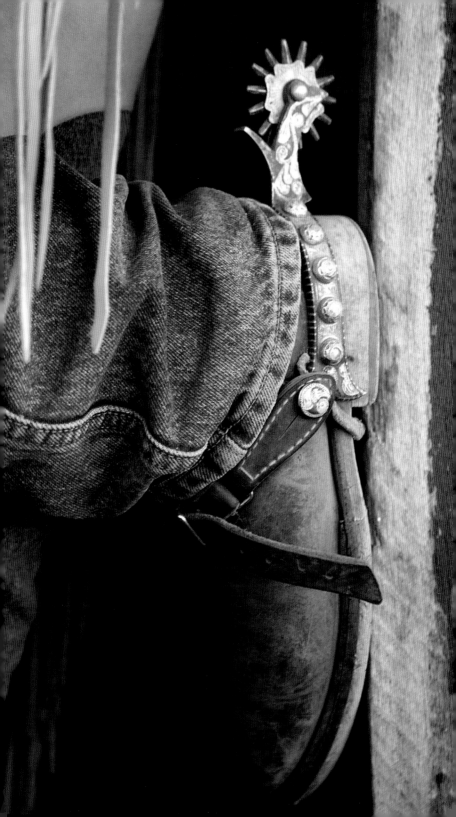

LESSON 7
Photographing Wildlife

In this lesson we'll explore some techniques for photographing wildlife. For the most part, you can also use these tips and techniques while shooting at a local wildlife park or zoo. For example, I photographed the lion on the opposite page while on safari, and I took the serval cat picture

Botswana

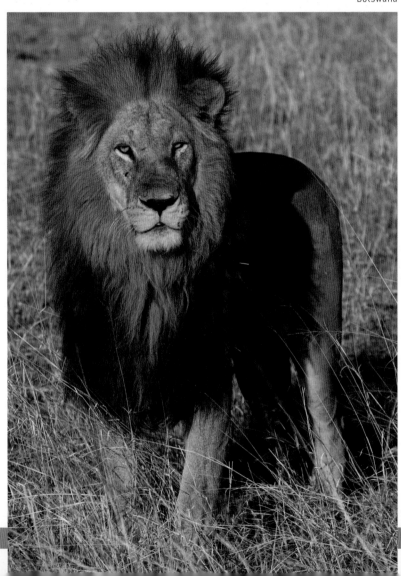

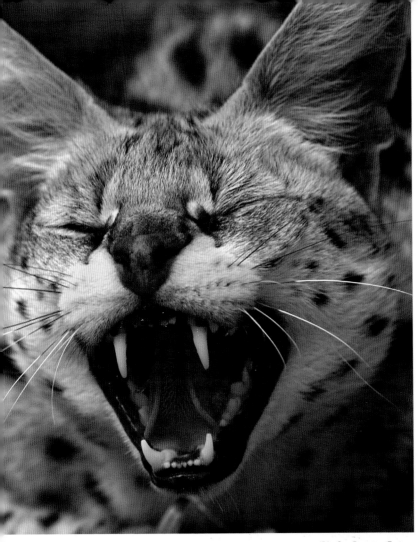

Big Cat Rescue, Tampa

in Florida. However, I used the same techniques—"the name of the game is to fill the frame" and "focus on the eyes"—for both.

I also used my 100–400 mm telephoto zoom lens for both pictures. Telephoto zoom lenses get you "closer" to a subject, so it's larger in the frame. For the lion photograph, I used a 1.4x teleconverter, which extends the range of a zoom lens, giving me an effective focal length of 140–560 mm. If you are serious about wildlife photography, I suggest investing in at least a 100–400 mm zoom lens and a teleconverter.

Let's begin our wildlife adventure. For the most part, we'll be in Botswana. We'll conclude our journey in Cape Churchill, Canada.

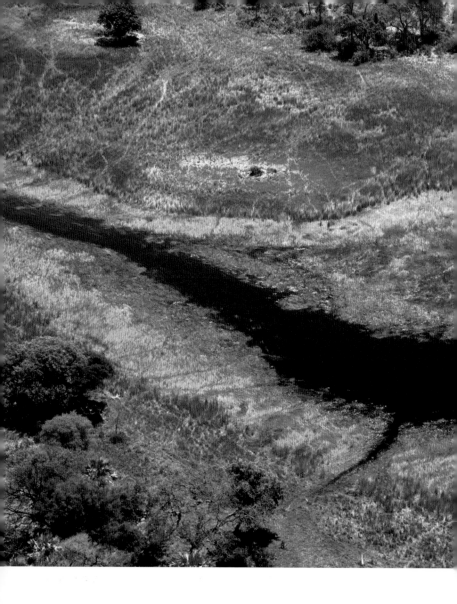

Establish the Location

When we take wildlife pictures—whether actually in the wild or at wildlife parks and zoos—it's important to establish the location. If we don't, the people with whom we share our photos will not have a good picture, so to speak, of the animals' habitat. As we'll see later in this lesson, close-up shots of wild animals sometimes cannot be distinguished

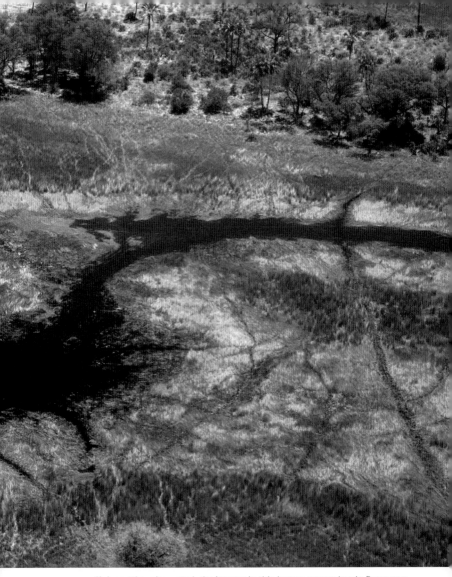

Unless otherwise noted, the images in this lesson were taken in Botswana.

from pictures of captive animals. That's why showing the habitat can be an important part of the story.

I took this aerial picture from a light plane while flying over Botswana's Okavango Delta.

Main Ingredients for Wildlife Photography

This picture of lions in courtship illustrates the main ingredients needed for successful wildlife photography: an expert guide who can find the animals for you, luck in finding wild animals, a good shooting position, a pleasing background and foreground, a knowledge of one's equipment, and above all patience—because sometimes we have to wait for days to get a perfect shot.

Almost all of the pictures in this lesson were taken with a Canon EOS 1D Mark II digital SLR and 100–400 mm IS (image stabilization) zoom lens, my prime lens for wildlife photography.

Some readers may ask why I do not use a much heavier and faster 300 mm or 400 mm f/2.8 lens and a tripod, which would steady the lens while shooting wildlife in action. The answer is simple: A zoom lens, which is lighter and smaller, offers much more composition flexibility when I am required to stay in the safari vehicle and out of harm's way.

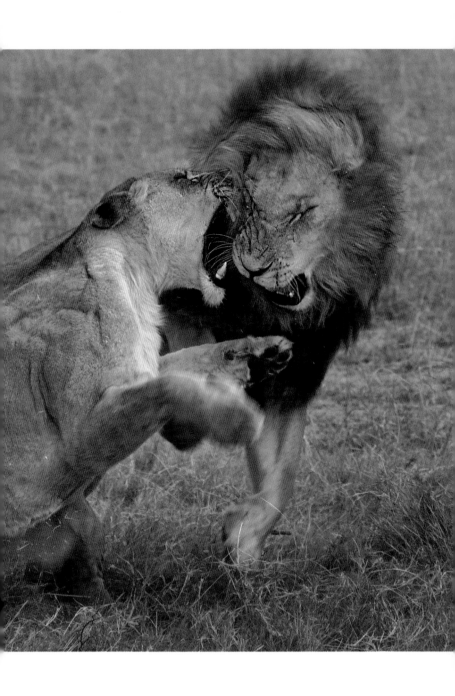

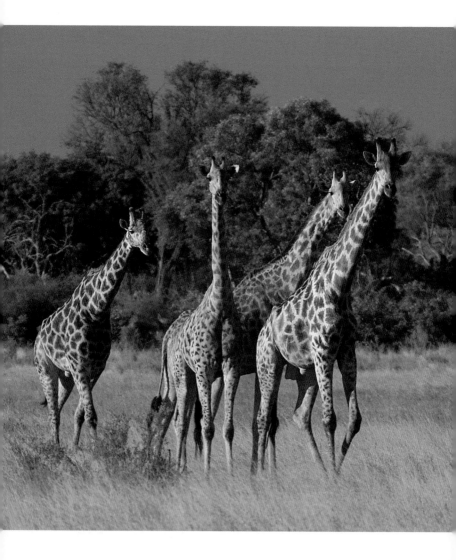

Look for Other Photo Possibilities

When we focus on a prime subject, it's important to look around for other photo opportunities that will help us tell the story of the entire scene. Here cautious giraffes observe the actions of the lions from a safe distance. My guide told me that giraffes know that lions don't hunt and eat during their three-day mating period. The giraffes' careful vigil adds another dimension to the mating lions' story.

Carefully Choose the ISO Setting

Digital images contain digital noise—what we call *grain* in a print or slide. As the ISO setting increases, so does the digital noise, which is most visible in shadow areas and sometimes in the sky. In most cases, point-and-shoot digital cameras have more noise at a high ISO setting than digital SLRs at the same setting.

As a rule, we should try to use the lowest possible ISO setting for the existing lighting conditions, because we usually want to minimize the noise in our pictures. On sunny days, we may be able to use low ISO settings, around 100 or 200. As the light level gets lower, we often need to boost the setting. On overcast days, we may need to shoot at ISO 400. When the sun is low in the sky, we may need to set the ISO at 800 or higher.

If we are shooting with a 300 mm or 400 mm nonstabilized telephoto lens on a sunny day, we may need to use a higher ISO, for a faster shutter speed that will avoid adding camera shake to our images. We might also consider using a smaller f-stop for more depth-of-field. Each lighting situation should be evaluated separately.

When in doubt about the ISO setting, ask yourself this question: Would I rather have a noisy picture, which may be acceptable and which may be able to be improved in the digital darkroom? Or do I want to risk a blurry picture caused by camera shake? I almost always find blurred subjects unacceptable. You may also want to ask yourself if noise, which can be added with

the Film Grain feature in Adobe Photoshop and Adobe Elements, can actually enhance a picture.

To illustrate how a high ISO setting can adversely affect digital noise, I set the ISO on my digital SLR to 1000 for this picture of two elephants at a watering hole at sunset. The picture has a lot of noise, especially in the dark areas of the image. The noise, combined with the fact that the animals are backlit, makes this an outtake that I would not otherwise publish.

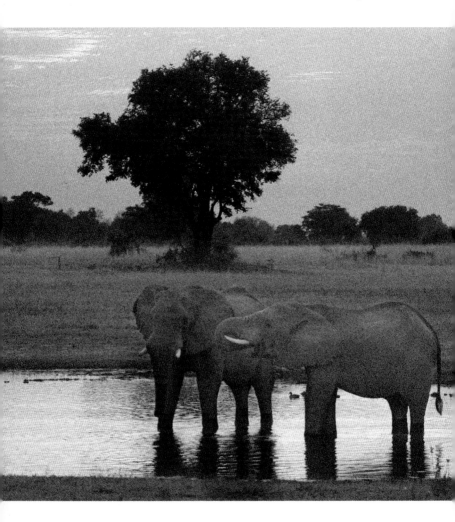

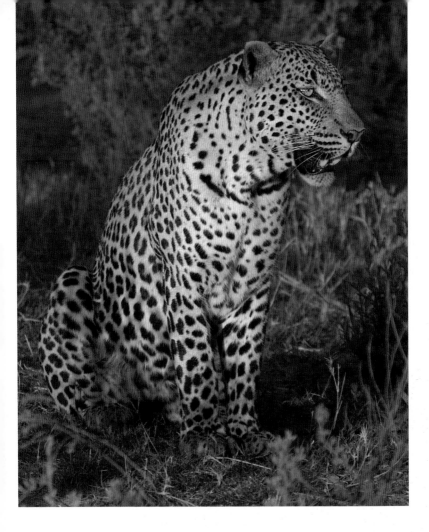

Shoot for the Sharpest and Cleanest Possible Shot

On the previous page, I showed the potentially negative effects of shooting at a high ISO. So I thought it only natural to show the effect of shooting at a low ISO setting.

I set my ISO to 100 for the photograph of this leopard, which was hunting in the strong, direct sunlight of late afternoon. That lighting condition and the ISO 100 setting helped to produce an image with virtually no digital noise, an image in which you can see every whisker on the big cat's chin.

See the Light

When you take a picture with your digital camera, you are recording light on the image sensor. No light, no picture.

Sunny days and overcast days offer different types of lighting conditions. To prevent disappointment with the lighting in our pictures, we need to learn how to "see the light."

On an overcast day, there won't be any harsh shadows, and pictures tend to look soft, which can be a pleasing effect. I photographed the resting male lion on a slightly overcast day. Notice how the soft light contributes to the image's peaceful quality.

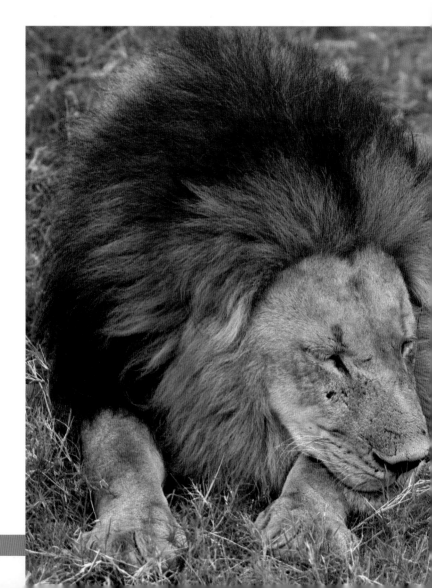

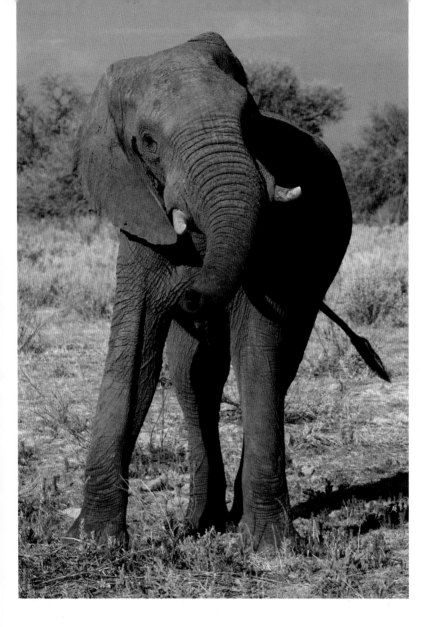

When we shoot on sunny days, our pictures have more pop, due to the strong shadows and increased contrast created by direct sunlight. On sunny days, I try to compose my picture so the light is falling on the subject's face, as was the case when I photographed this elephant in a mock charge.

For more on seeing the light, see lesson 5.

Look for Shadows and Highlights

In addition to seeing the quality of light, we need to see the highlight and shadow areas of a scene—something our cameras can't see as accurately as our eyes can. In this example, part of the lionesses' faces is shaded and therefore darker than their bodies, which may not be the most desirable lighting effect, but one that does bring more attention to the powerful shoulders and legs of these magnificent creatures.

Always remember that, if the available lighting isn't perfect, we can reverse the highlight and shadow areas of a scene (to some degree) in Photoshop. In my digital darkroom I not only lightened the animals' faces and darkened their bodies, but I also darkened the background to draw more attention to the animals.

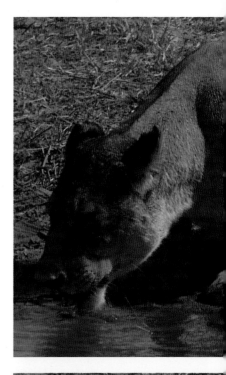

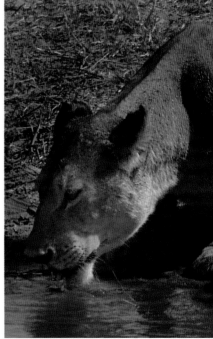

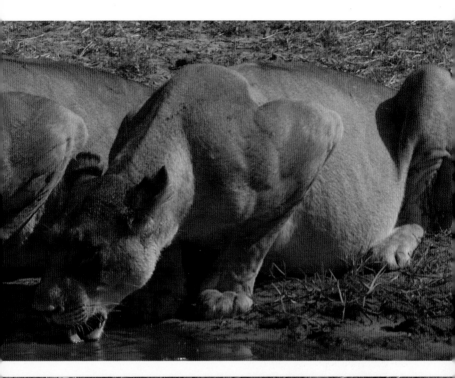

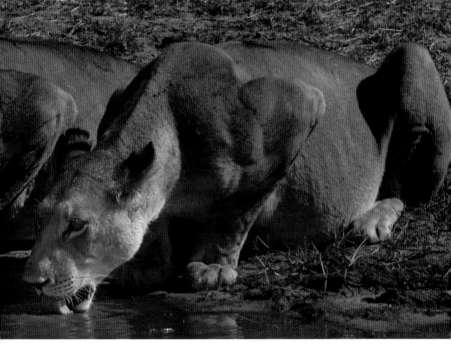

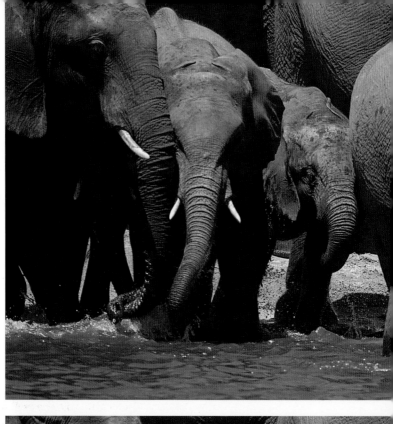

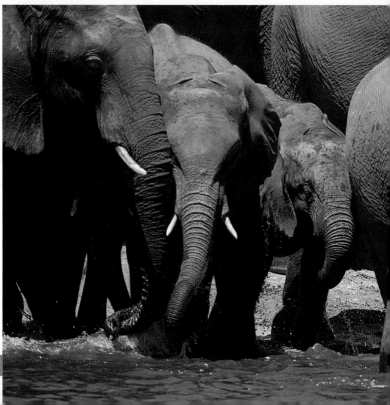

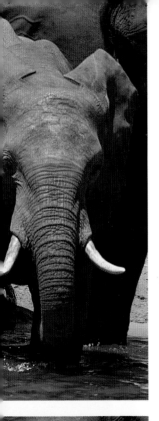

Set the White Balance

Digital cameras allow us to set the white balance for the existing lighting conditions. When we set the white balance, we are defining for the camera which objects in the scene are to be white. If the white objects are recorded as white, then all the other colors in the scene should be accurately recorded by the camera.

Because I mostly shoot RAW files, I can change the white balance for an image using Photoshop's RAW plug-in on my computer. If you shoot JPEG files, I recommend setting the white balance for the existing lighting conditions—sunny, cloudy, shade, and so on.

Here you see the effect of changing the white balance. The warmer picture (yellow tone) shows the effect of using the Cloudy setting in daylight conditions. The cooler picture (gray tone) shows the effect of setting the white balance to Sunny, which was the existing lighting condition.

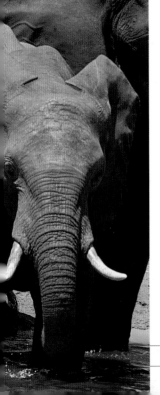

Use Daylight Fill-in Flash

A flash is very useful for wildlife photography, because we often find subjects with back, side, or top lighting, or find the subject in the shade.

Master the basics of using daylight fill-in flash, which I outlined in lesson 6. The more you use it, the more you will value the results.

Here you see the effect of using daylight fill-in flash. The first photo shows the results without. In the second, I simulated the fill-in-flash effect in Photoshop (using the Shadow/Highlight control). Even though the effect can be achieved in Photoshop, it's always best to start with the best possible in-camera image.

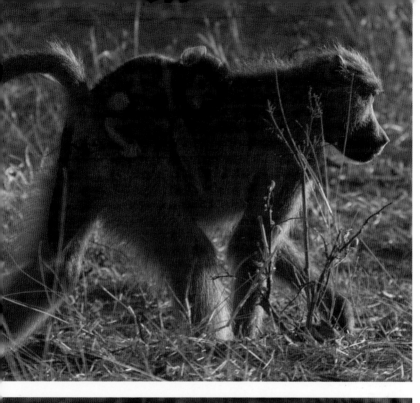

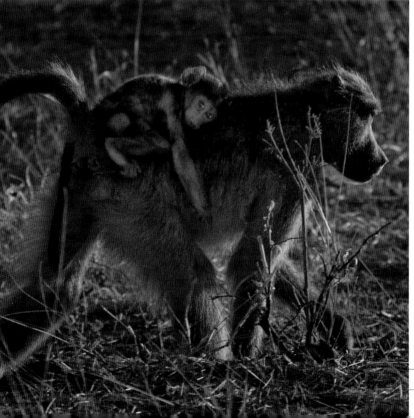

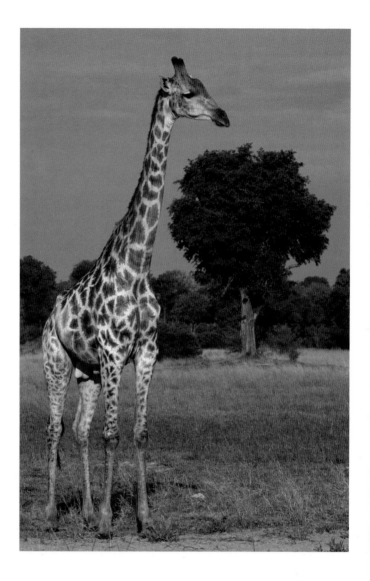

Watch the Background

It's important not to lose sight of easily overlooked compositional elements. In landscape photography, the foreground is important to consider, because it can add a sense of depth to a scene. In wildlife photography, the background is important, because it can enhance or detract from the main subject.

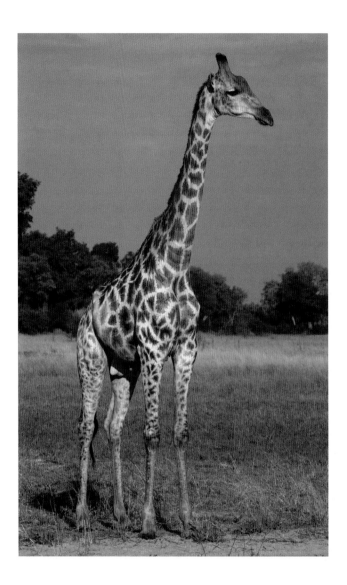

I like both of these pictures. The portrait of the giraffe showing the head framed against the sky is the type many photographers would take. However, the picture framed with the tree in the background shows creative composition. In addition, the tree may have provided lunch for the giraffe, adding yet another storytelling element.

Behavior Pictures vs. Portraits

Animal portraits are fun to take. By portraits, I mean an image in which the subject is at rest. However, showing animal behavior is often more interesting. Admittedly, we often have to wait for an animal to exhibit behavior. The lioness giving the lion a love bite during courtship on page 131 is one of my favorite behavior shots. The elephant's mock charge on page 137 also reminds us that elephants can outrun a man and easily flip over a safari vehicle.

This giraffe photo is also one of my favorite behavior pictures. It shows the strong legs of the giraffe, and helps us visualize how its rear legs are forceful enough to kill a lion with one swift kick, yet can also be ungainly obstacles to, say, getting a quick drink at the local watering hole.

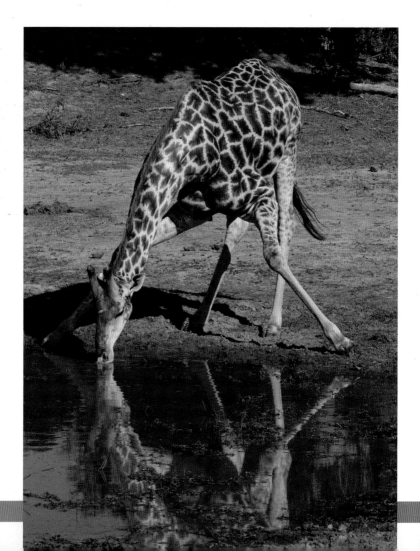

Photographing Birds in Flight

For maximum detail, we want to get relatively close to the bird. Therefore, we need a telephoto lens or a telephoto zoom in the 200–400 mm range, maybe even longer. Adding a 1.4x or 2x teleconverter, which increases the effective focal length of the lens, is an additional option.

Because the bird will be moving at high speed and moving in all different directions, we'll need to shoot at a high shutter speed—at least 1/2000th of a second or maybe even higher when we want to "freeze" the bird in midair (more on this in a moment). That may require an ISO setting of 200 or 400 on a sunny day. To determine if a high shutter speed will be available for the ISO set, take a test exposure reading on the resting bird, if you are lucky enough to catch the bird at rest. If the shutter speed is too low, increase the ISO setting.

The f-stop is also important. If the lens is set at the widest aperture, the depth-of-field will be limited, especially when using a telephoto lens. To expand the area of focus in front of and behind the bird's body, try stopping down to f/5.6, f/8, or even smaller.

As with the shutter speed, if there isn't enough light for an f/5.6 or f/8 aperture, boost the ISO.

There's a better chance of getting the fast-moving bird in focus if we use the focus-tracking feature (as opposed to focus lock) on our SLR cameras, because that setting tracks the subject until the moment of exposure. With focus lock, the subject can move out of the frame once the focus is locked.

When it comes to frame advance, set the drive mode to high speed, to take an action sequence while holding down the shutter release button. That way more moments of the flight can be captured, with more opportunities to bag a keeper.

Crop Creatively

As you may have realized from flipping through this book, I am a nut about cropping. I seldom use the full frame image that I captured in-camera. Rather, in the digital darkroom, I crop out areas that I feel don't add anything to the scene.

Here are two examples that illustrate my thinking on cropping. Each of the pictures had dead space on the top and bottom of the frame that detracted from the impact of the main subjects. I cropped out this extra space, because it didn't contribute anything in the way of a backstory or sense of place.

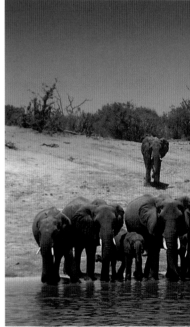

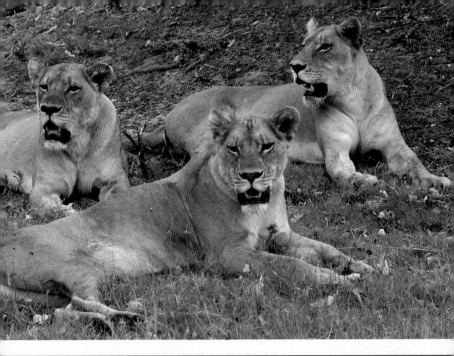

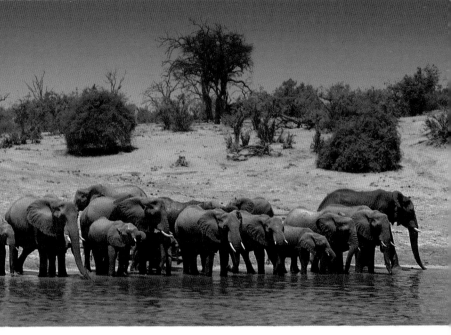

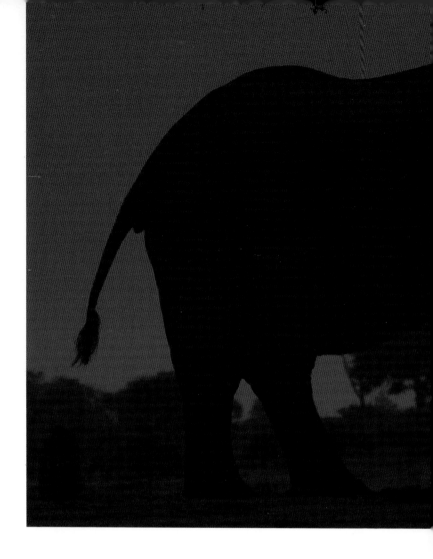

Silhouettes at Sunset

Sunsets offer a wonderful opportunity to take dramatic wildlife silhouettes. The key is to frame the scene so the sun or part of the bright sky is behind the animal.

For dramatic sunset silhouettes, I recommend setting your camera on Program and then take pictures with the exposure compensation set at –1, then –1 1/2 and –2 (and in between those settings if you want to fine-tune your exposures). The reduction in exposure will give you saturated colors and make the silhouette more dramatic. It also helps keep the sun from becoming overexposed, which can ruin a picture.

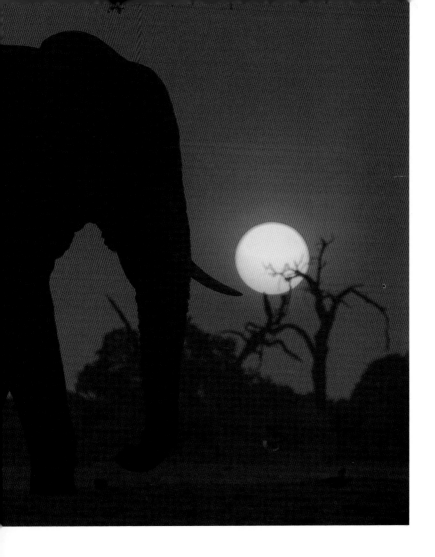

Setting the white balance to Cloudy will also give more dramatic colors than if the white balance is set to Auto.

As the sun gets lower in the sky, it's necessary to increase the ISO setting. For this picture of an elephant at a watering hole, I had my ISO set at 400.

One final tip on shooting sunsets: Wear sunglasses, and don't look directly into the sun. If you look into the sun for just a second or two, you will be seeing red blotches for several minutes. What's more, you could cause damage to your retina, which could severely limit your picture-taking!

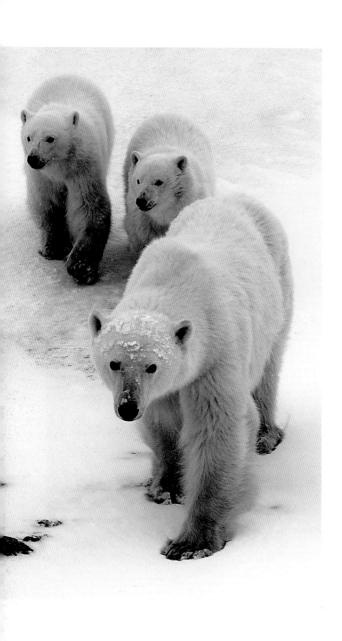

Shooting in Chilly Conditions

I thought I'd end this lesson with two of my favorite wildlife pictures from Cape Churchill. Shooting in the snow presents certain challenges, which I discuss in lesson 15.

All of the aforementioned techniques for photographing wildlife apply when shooting in the snow. One difference is that you may need to work faster, because the cold limits your time outdoors.

Speaking of snow, to get snow to look white, set your camera's white balance to the existing lighting conditions: Sunny when shooting on a sunny day, Cloudy when shooting on overcast days. If you mess up and forget to set the correct white balance, you can get the snow to look white by adjusting the color balance in Photoshop.

Cape Churchill, Manitoba

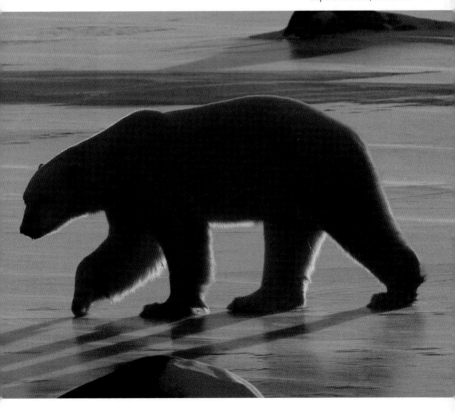

Scenic Views

Photographs of scenic views have the power to transport us from our desks and computer monitors to the great outdoors, instilling a sense of peace and tranquility, even if only for a few moments.

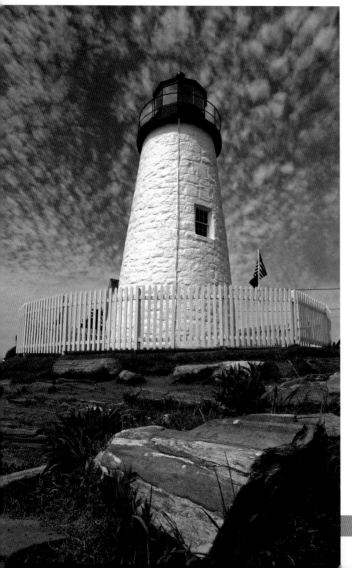

Maine

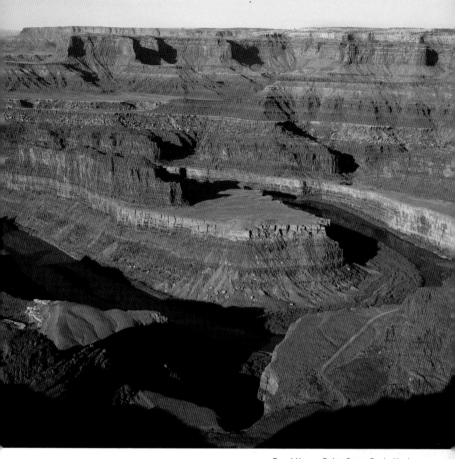

Dead Horse Point State Park, Utah

In this lesson I'll share with you some of my favorite landscape and seascape photographs; the principles I'll discuss for photographing each are basically the same.

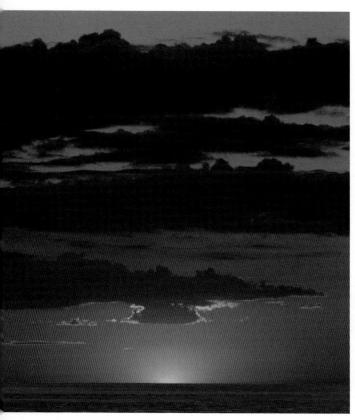

Maine

Keep the Horizon Level

In scenic photography, it's important to keep the horizon level. Believe it or not, when I review portfolios, tilted horizon lines in landscape photos show up more than one might think, which can distract from an otherwise beautiful picture. If you have trouble with the horizon line, small bubble-levels are

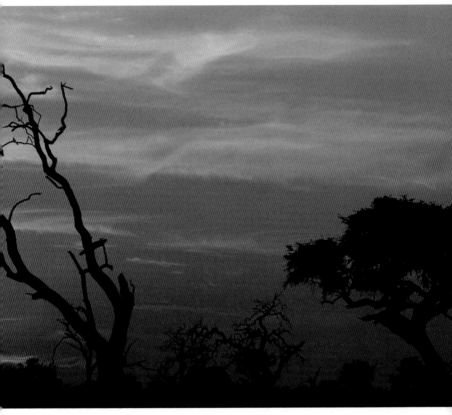

Botswana

available that fit into a camera's hot shoe, where you usually place an accessory flash.

If you don't have a bubble level, bring the bottom of your viewfinder up until it is level with the horizon line. Then carefully tilt your camera up or down, keeping a keen eye to see that the horizon line stays level.

Cut the Clutter

Oftentimes we are so overwhelmed with the beauty of a scene that we try to capture everything into one big picture. While it is possible to capture an entire scene in one photo, sometimes big picture images look cluttered, with too many different subjects competing for attention. In order to compose a picture that will not be distracting or overwhelming, select a main subject, such as this lone tree, and frame the photograph to emphasize it.

Even a landscape picture can have a starring role.

Botswana

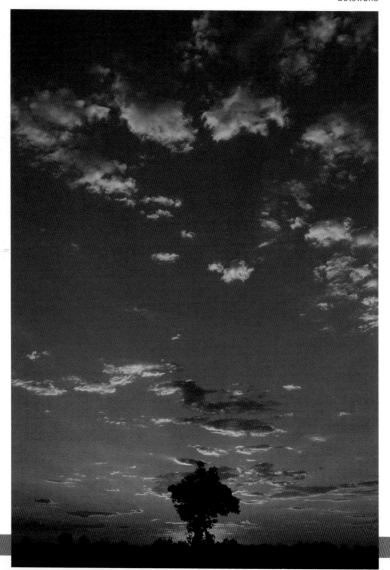

Shoot during the Golden Hours

Professional landscape photographers prefer to shoot early in the morning and late in the afternoon, calling these times "the golden hours." During these beautiful hours, the quality of sunlight is warmer, making pictures look softer and more pleasing than pictures taken at midday, when the light is cooler. What's more, long shadows in the early morning and late afternoon add a sense of depth and dimension to landscape photographs.

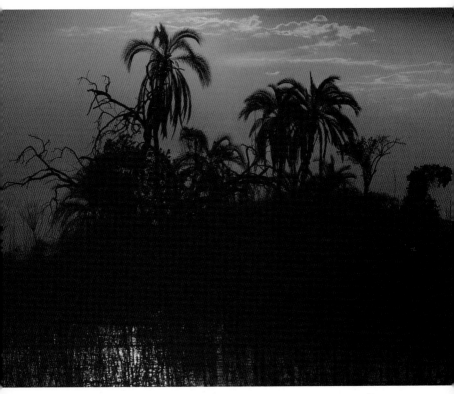

Botswana

Warm up digital pictures by using the Cloudy white balance setting, which I used for this photograph taken while on safari.

Go Wide and Shoot Small

Landscape photography is about capturing the view. To capture the wide view, we need a wide-angle lens, usually in the 16–28 mm range of effective focal length. For maximum depth of field, shoot at a small aperture, usually at or smaller than f/11. That may require using a tripod, because as we decrease the aperture we also lengthen the related shutter speed. Tripods are helpful in landscape photography, if for no other reason than they slow you down and help you live in the moment.

For this picture I used my Canon 16–35 mm zoom lens set at 16 mm

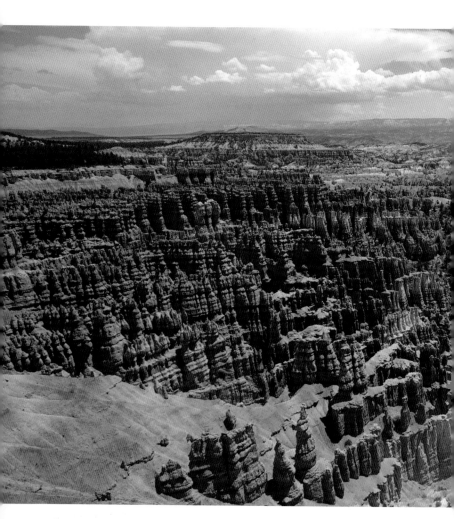

on my Canon EOS 1Ds. The digital SLR camera features a full-frame image sensor, the same size as a 35 mm film side or negative would be, and so the effective focal length of using a 16 mm lens is 16 mm. My aperture was set at f/11. As you can probably tell, I cropped off the top and bottom of the frame for a somewhat panoramic picture, something I had envisioned when looking through the viewfinder. When composing landscape pictures, it's a good idea to visualize how cropping can enhance the scene.

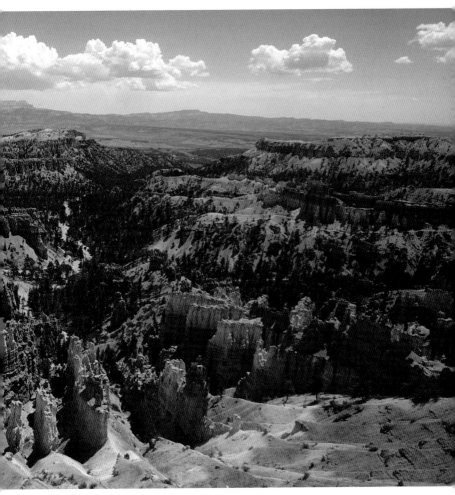

Bryce Canyon National Park, Utah

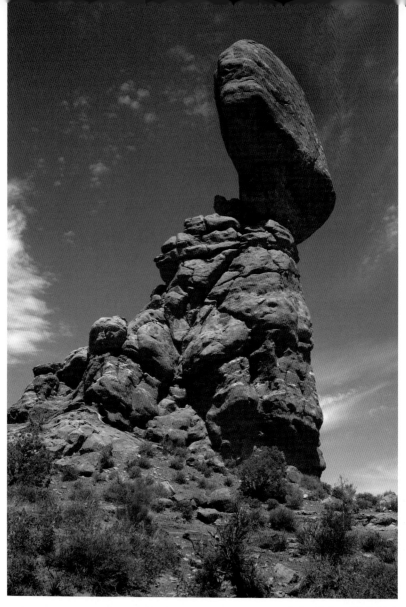

Arches National Park, Utah

Shoot When It's Sunny and When It's Not

Most of us love to shoot on bright days, when the sun is warming our mind, body, and soul. If we have an interesting subject, we can easily get dramatic pictures. However, we can also capture interesting landscapes when it is overcast, misty, or foggy.

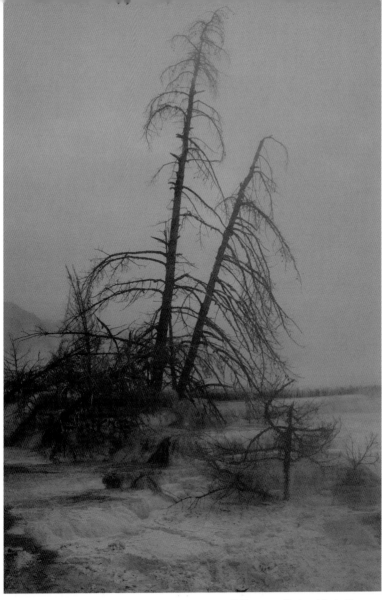

Yellowstone National Park, Montana

I took the picture of Balanced Rock on a sunny day (see opposite page), and I photographed the above scene near a hot spring early one misty and overcast morning. The pictures each have a different feel, capturing the moment; both are dramatic in their own ways.

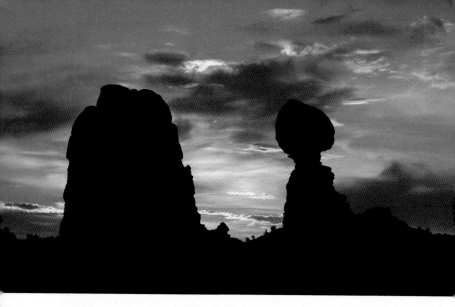

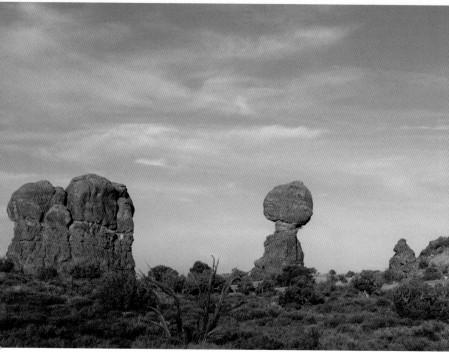

Arches National Park, Utah

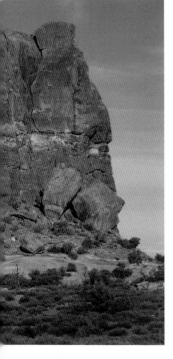

Take Your Time, Shoot a Lot

When it comes to landscape photography, we need to think about all the technical aspects of photography: lens selection, aperture, shutter speed, and so on. However, it's also a good idea to shoot a lot: Take pictures of the same site or at the same locations throughout the day. As the day progresses, the color of light in the sky and on the landscape changes, and shadows grow and shrink. The more we shoot, the more variety we'll have, and the better chance we'll have of getting the most dramatic image of a particular scene.

Both of these pictures show the same rock formation, just at different times of day and from different viewpoints.

Don't Get Locked In

The rectangular ratio of height and width of our camera's digital image sensor does not necessarily lock us into those dimensions. When I saw this sunset scene, I envisioned cropping out the dead space for a photograph with more impact.

Here I cropped out some of the top and bottom of the frame in the digital darkroom for a panoramic image. Always keep future cropping in mind while composing a landscape scene.

Cape Cod, Massachusetts

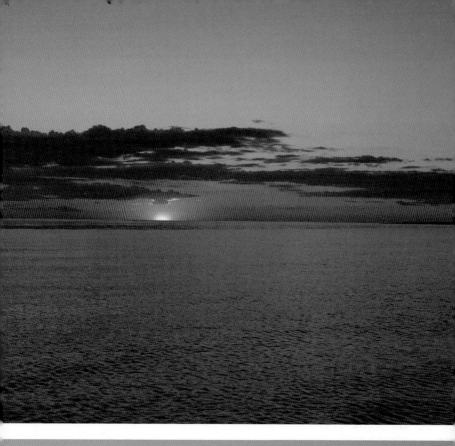

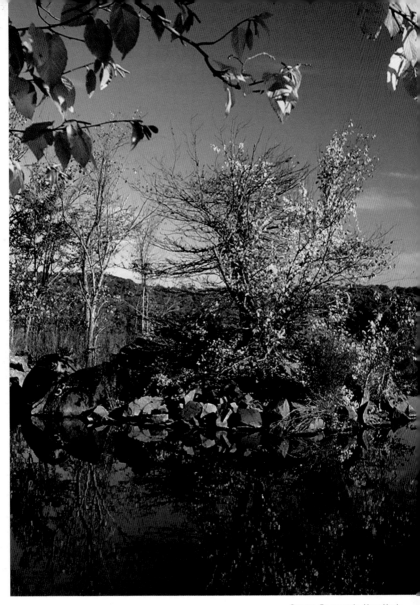

Croton Reservoir, New York

Pack a Polarizing Filter

To shoot scenics, we must have a polarizing filter. A polarizing filter lets us dial out reflections on water and can also darken a blue sky and lighten white clouds. Polarizing filters are most effective when the sun is off to the side; they're not effective at all when the sun is directly in front of or

Maine

behind the camera. If you have a skylight filter (designed to filter out the bluish cast of sky light) on a wide-angle lens, remove it when shooting with a polarizing filter. Leave it on, and there may be some vignetting (darkening) in the corners of the picture.

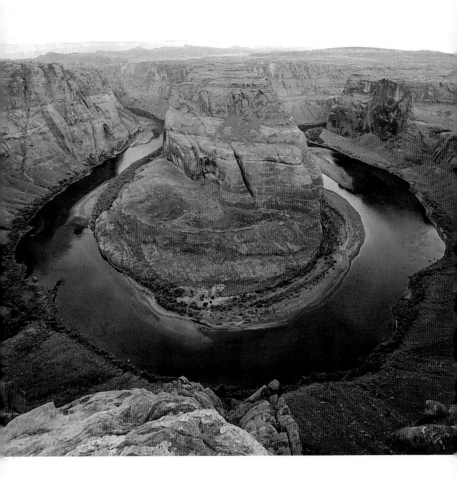

Go for a Graduated Filter

When the sky is much brighter than the landscape, as it was when I photographed Horseshoe Bend, a graduated neutral-density filter can reduce the contrast range in the scene for a more even exposure. Graduated filters are darker at the top, becoming lighter and eventually clear at the bottom (or vice versa if you hold them in the opposite position).

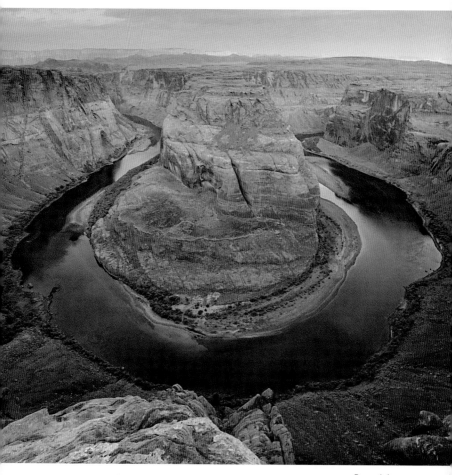

Page, Arizona

Like a polarizing filter, a graduated filter is necessary for landscape and seascape photography. They come in different densities, different colors, and different grades—from a soft transition to a hard transition. Have fun experimenting!

Zion National Park, Utah

Get Movin'

When I travel, I like to shoot a set of pictures that illustrates how simple techniques can improve a picture. In this set, see how moving a few feet sideways can make a big difference in the

photograph's composition? In the picture with the small rock formation in the center of the frame, the composition is centrally anchored, less-than-pleasing. By moving a few feet to my right, I could compose the shot with the same rock formation off to the side of the frame, for a much more dynamic exposure. Notice how your eyes are guided around the image, taking in the foreground and background subjects. If you keep moving, you never know when a new, exciting composition will emerge.

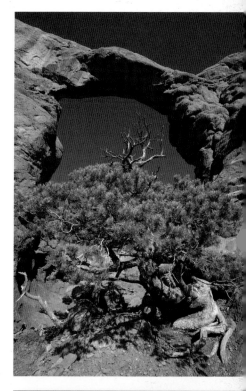

Move On Up, and Down

Here is a set of pictures that also illustrates how moving just a bit can dramatically change the composition (vertically this time). I took the first picture while crouched down on the ground closer to the tree, and the second one while standing up straight, farther away. In this case, I like both photographs because both capture the beauty of the scene.

Arches National Park, Utah

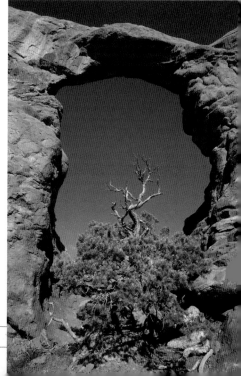

Add a Foreground Element and Focus Carefully

Shadows can add a sense of depth to a picture. Another way to create a sense of depth is to include a foreground element in the scene. In this example, I framed the Grand Canyon with the trunk and branches of a tree.

When there is a very near foreground element, having all the elements in the scene in focus is essential. Use a wide-angle lens and set a small f-stop to gain breadth and depth. In addition, we need to know where to focus for maximum depth of field. Generally speaking, focus one-third into a scene with a wide-angle lens and small f-stop, and you should attain sharpness throughout the scene. Keep in mind, however, that if foreground elements are just a few inches from the lens, it may be hard to get both foreground and background in sharp focus.

Grand Canyon, Arizona

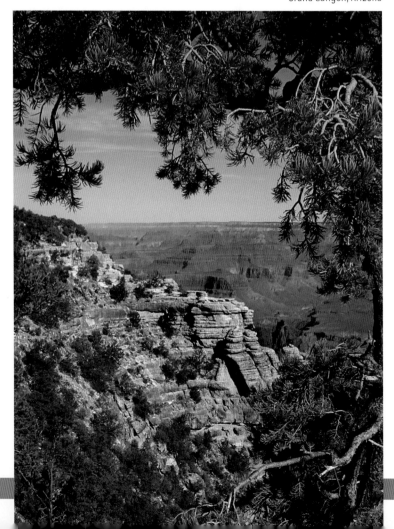

Zion National Park, Utah

Choose the Foreground Element Carefully

The huge boulder in the foreground of this picture dominates the scene. From an artistic standpoint, a boulder that overtakes the majority of the composition may not have been the best choice for a foreground element. However, from a scientific narrative standpoint, the foreground shows how the boulder was cut by nature: the surface facing the camera is almost perfectly smooth and flat. This boulder is sedimentary rock, and its formation dates back to when the area was covered with an ocean. Heat and pressure from shifting plates pushed the old sea bottom upward. Erosion over millions of years created this marvelous natural sculpture. As with the example on page 174, the entire scene is in focus, thanks to careful focusing one-third into the scene.

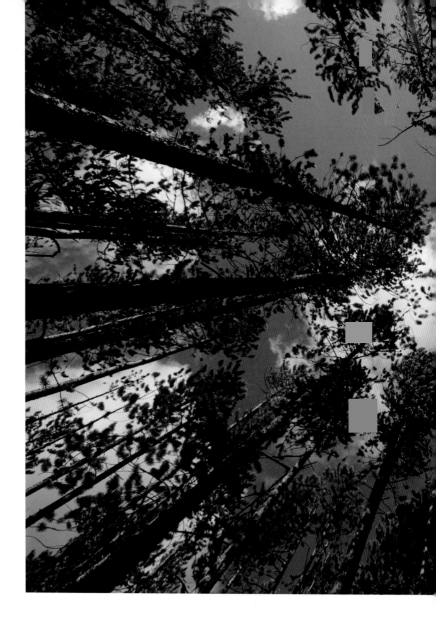

Look Up

Oftentimes we are in such a rush to get to a specific location that we don't look around—and up—for other picture opportunities. This pine tree scene illustrates what can happen when we take the time to look up and photograph what we see. Here I used the 16 mm setting on my 16–35 mm zoom lens to create this dramatic effect.

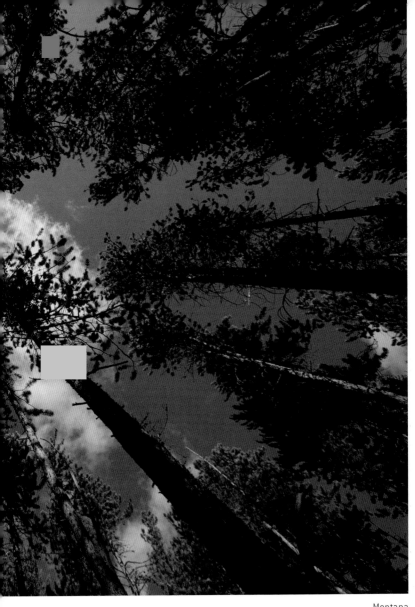

Montana

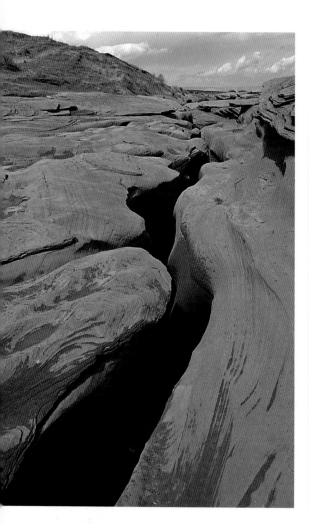

Be a Storyteller

Good photographers tell a story with their pictures. How much of the story we tell is up to us. Sometimes it's a single picture, other times it's a series of pictures.

When shooting, it's important to think about the story you want to share with family, friends, or readers. Here are three pictures that help tell the story of the Lower Antelope Slot Canyons.

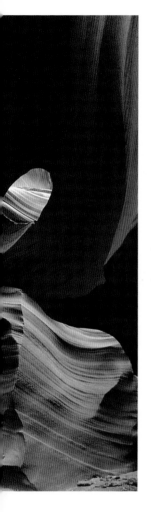
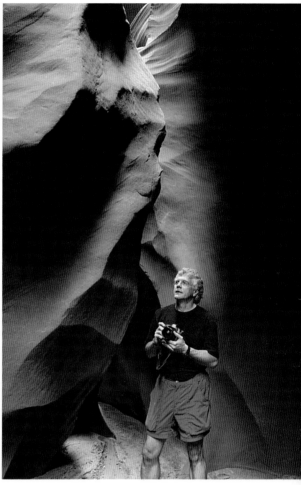

Page, Arizona

The first picture shows the very narrow slot that visitors have to shimmy down on a ladder to get into the canyon. The second shot shows the beauty of the canyon walls. The last shot shows the scale of the canyon, as well as an autobiographical expression of what it feels like to observe the light streaming onto the canyon walls. Combined, the pictures show what someone visiting the canyon might expect.

Photographing Sunsets and Sunrises

Sunsets (as well as sunrises) often evoke emotion.

When I shoot a sunset, I often underexpose the scene by an f-stop for more dramatic color, and to avoid overexposing the area around the sun.

I also like to shoot sunset and sunrise scenes when the sun is not in the frame. To do that, you'll wait until the sun is below the horizon line. You can get some beautiful sunset pictures after the sun has set. Use a tripod to steady the camera during long exposure, and boost the ISO to record the lower light levels.

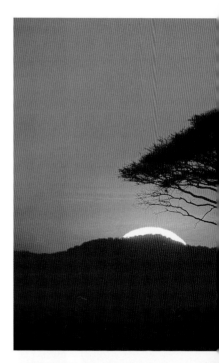

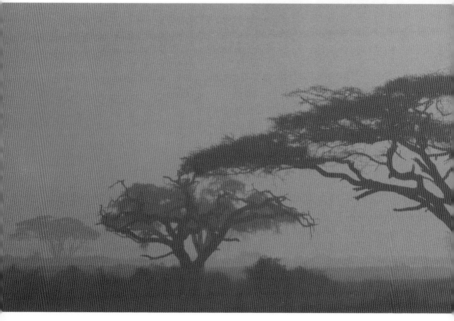

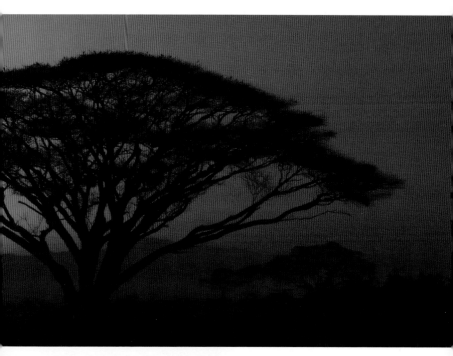

Kenya

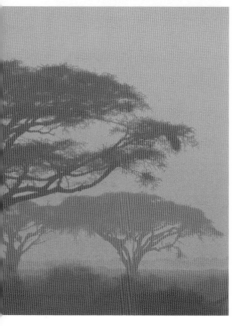

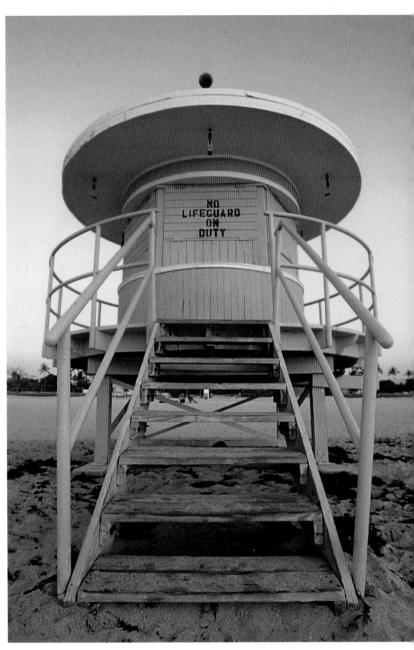

South Beach, Miami Beach, Florida

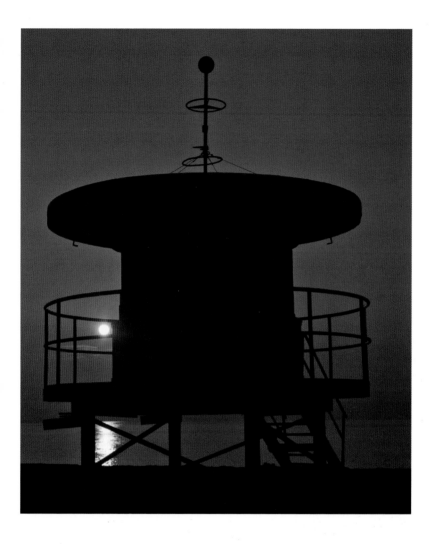

You Snooze, You Lose

Here is a very important tip for landscape and seascape photography: You snooze, you lose. You need to get up early and stay out late to catch the most beautiful light.

When I am on location, I shoot from before sunrise until after sunset so as to maximize the available time. When I come home, I catch up on the sleep I missed while seizing each hour of daylight on the road.

If I had snoozed when I was on location in South Beach, I would have missed the more dramatic of these two photographs.

Indoor Flash Photography

In this lesson I'll share with you some of my techniques for getting good pictures indoors using a flash.

Let's start with a brief, general discussion of flash photography.

One of my main objectives when taking an indoor flash picture, and

even an outdoor flash picture, is to have the picture look like it *isn't* a flash picture. To achieve that, light from the flash must be balanced to the available light, a technique which I covered in lesson 6.

Compare these two pictures of my son, Marco. The picture on the opposite page illustrates successful daylight fill-in flash photography. No shadows! The picture on this page illustrates what happens when the flash is not balanced to the available light. The shadow distracts from what would otherwise be a nice picture.

Let's talk a bit more about how to use a flash indoors.

Use a Flash Diffuser

Here I am showing Annie Leibovitz (in a wax likeness at Madame Tussauds in New York) the flash system I use to reduce the harsh shadows in flash pictures. Look closely and you'll see that my flash is mounted on a bracket that lets me position the flash relatively high above the lens. The flash is attached to the camera with a coil synch cord. The bracket swivels counterclockwise, so even when I'm taking a vertical picture, my flash is above the lens. Keeping the flash above the lens ensures that the shadow from the flash falls behind the subject, not next to it. What's more, I have a flash diffuser mounted over my accessory flash. The diffuser softens the light for a more natural effect.

Note that a flash diffuser reduces the maximum flash range. If you want to increase the flash range to compensate, boost the ISO.

Reduce Red-Eye

Red-eye is caused by the light from a camera's flash reflecting off the retina, and can happen when a flash picture is taken of a person in a dark room. The darker the room and the closer the flash is to the lens, the more pronounced the red-eye effect. Blond-haired, blue-eyed

Quality	RAW
Red-eye On/Off	On
AEB	-2..1..0..1..2+
WB-BKT
Beep	On
Custom WB	
Parameters	Parameter 1

people tend to show red-eye more often than other people. To illustrate the red-eye effect, I photographed my son's friend Adrian in a dark room with a camera that has a flash close to the lens.

There are several ways to reduce or eliminate red-eye: Make the room as bright as possible, or have the subject stand near a light source, such as a lamp. The result is that the amount of light is increased, and the eye responds by "stopping down," as the pupils contract. Other methods to reduce red-eye include using a flash coil cord to position the flash off-camera, using the camera's red-eye reduction feature, or asking the subject to look slightly away from the lens.

I used several of the aforementioned techniques to eliminate the red-eye effect when photographing Adrian.

Indonesia

Watch for White

White objects, such as this performer's mask, can fool a flash into underexposing a subject, because the camera and flash think the subject is brighter than it actually is.

To prevent underexposing a white subject, increase the flash exposure (usually by +1) either in-camera or on your accessory flash.

Avoid Flash Reflections

Taking a natural light picture though glass is hard enough. Adding a flash adds another challenge.

To reduce the reflection of the flash on the glass, shoot at a 45-degree angle. The flash will bounce away from your camera, not toward it.

Shooting close to the glass and cupping your hand around the lens also helps to prevent reflections from ruining your picture.

Bronx Zoo, New York

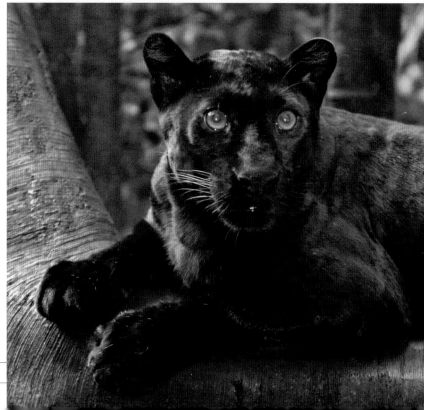

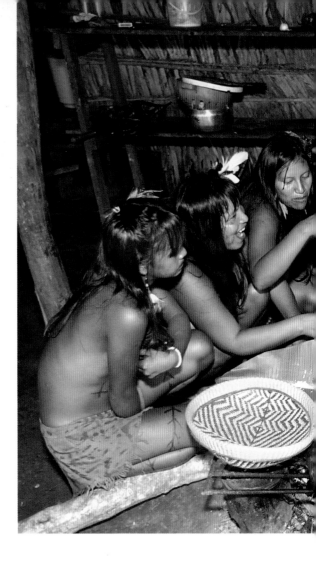

Pack a Backup Flash

If you are serious about taking indoor flash pictures while traveling to an exotic place, here is some good advice: Take a backup flash unit.

Had I not had a backup while shooting in a Taraino village, I would have missed photographing this traditional meal—fish wrapped in a palm leaf and steamed underground. My other flash unit had just died.

Several things can prevent a flash unit from working properly: the batteries can leak and corrode the connections, the hinges of the battery compartment door can come loose, the plate that holds the

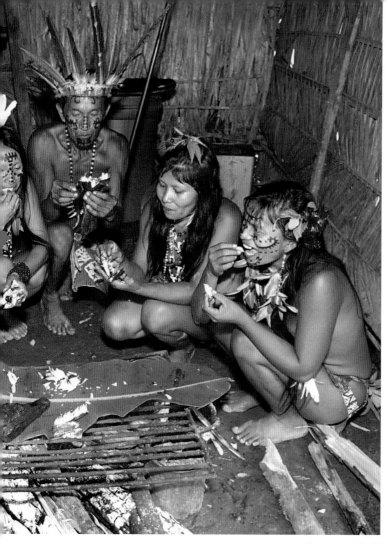

Amazonas, Brazil

flash to the hot shoe can become loose or break off, and the electronics can get zapped (often by moisture)—causing an internal short, which may prevent a feature or several features of the flash from functioning.

If you use rechargeable batteries, take a backup recharger, just in case your primary charger gets zapped in a power surge (which happened to me on a boat in the Galapagos). Having a backup meant I didn't skip a beat.

Indoor Available Light Photography

When traveling, we often find good photo opportunities indoors, but the low light or artificial light presents special challenges. In this lesson I'll share some tips for maximizing indoor opportunities.

Carmel, New York

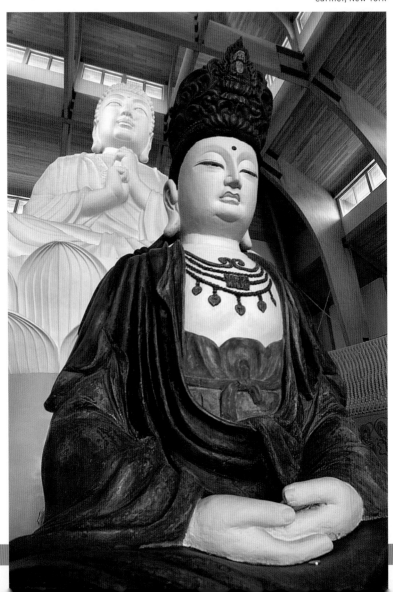

Singapore

Both of the pictures on this spread were taken in Buddhist temples. For both low-light pictures, I set my ISO to 800. The image sensor's increased sensitivity to light let me shoot at a shutter speed of 1/30th of a second. With my 16–35 mm lens set to the 16 mm setting, the shutter speed was fast enough for a handheld picture. The basic rule for a handheld shot is this: Don't use a shutter speed slower than the focal length of the lens. If you do, camera shake may cause a blurry exposure. Image stabilization changes all that, and you can shoot at two or sometimes even three steps below the recommended shutter speed with image stabilization engaged.

Go Wide

In many cases, wide-angle lenses are a good choice for indoor photography. They let us shoot at a slower shutter speed than telephoto lenses and are less likely to exaggerate camera shake. Wide-angle lenses also provide greater depth of field than telephoto lenses. Wide-angle lenses let us capture more of a scene. This is a big advantage when working in confined quarters, because wide-angle lenses can also make a relatively small room appear much larger. I took this picture of the room in which I stayed at the River Club on the Zambian side of Victoria Falls with my 16–35 mm zoom lens set at 16 mm.

Zambia

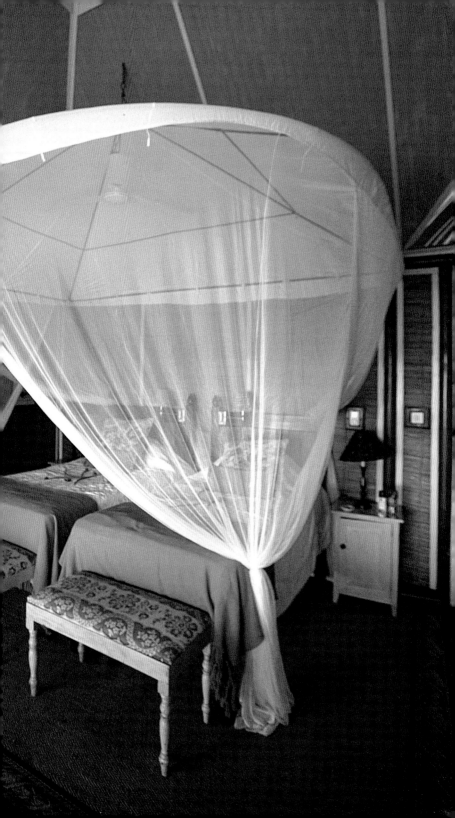

The Fast Lens Advantage

If you plan to do a lot of indoor photography, you probably want to invest in a fast f/2.8 or even f/1.4 lens. Fast lenses let more light into your camera. More light means two things. First, you can use a faster shutter speed, which will help prevent blurry handheld pictures. Second, you can use a lower ISO for pictures with less digital noise.

Both of these pictures were taken in low light with fast lenses; there was no need for a tripod.

Set the White Balance

After setting the ISO, the next consideration for indoor photography is setting the white balance—if you shoot JPEG files. If the whites look clearly white, then theoretically all the other colors in a scene should be reproduced faithfully.

If you shoot RAW files, the white balance is not embedded in your digital file, and you can easily set it in the digital darkroom.

When shooting under mixed light sources, I recommend setting the white balance to Auto.

In situations when there is only one main light source, set the white balance to the existing lighting condition: Fluorescent, Tungsten, and Flash are the most common.

For this shot of my son, Marco, playing chess, I used the Auto White Balance setting, because we were in the kitchen, and the light sources included sunlight, fluorescent, and tungsten.

If you are not pleased with the colors in your pictures, you can always correct them in the digital darkroom.

Shooting through Glass

Have you ever tried to shoot through glass? If you have, you know it's a challenge.

First, the light level is often reduced even further, as was the case when I photographed this leafy scorpionfish.

The best bet for natural light photography is to cup a hand around the camera lens and press the hand on or close to the glass. That will block out surrounding reflections.

When it comes to white balance, Auto is a good choice, because the lighting conditions will probably be mixed.

In choosing a lens, try a wide-angle lens and small f-stop for good depth of field.

In very low light conditions, you may find that your autofocus camera will not focus. Switch your camera to manual focus.

Undoubtedly you will run into challenges in your indoor photography, but the resulting pictures can be worth the care and effort needed to take them.

Monterey Aquarium, California

Onboard the *Constellation*

Shooting Stage Shows

Photographing stage shows presents its own set of special challenges. The light level is usually very low, forcing us to use very high ISO settings, sometimes as high as 1600. Even when using a high ISO setting, we still need to shoot slow shutter speeds, sometimes as slow as 1/60th of a second. We can't always get close to the performers, so we need to use telephoto or telephoto zoom lenses. Finally, even if we were allowed to use a flash, we probably would choose to use the available light, because the flash would destroy the mood of the scene.

I took this available light picture of a Cirque du Soleil performer aboard the cruise ship *Constellation* with my digital SLR set at ISO 1600. For a steady shot in the low–light/low–shutter speed conditions, I used my Canon 70–200 mm IS lens.

Using a Tripod

I don't like lugging around a tripod. But there are times when it's a lifesaver, or at least a picture saver. For this picture, taken inside the Venetian Hotel I needed a tripod, because of the low light level and the slow lens that I was using (f/3.5–4/4.5).

When using a tripod, it's a good idea to use the camera's self-timer to release the shutter, which helps prevent camera shake. Locking up the camera's mirror, something you can do on many digital SLRs, also helps prevent camera shake.

Las Vegas, Nevada

Madame Tussauds Wax Museum, New York City

Try to Go Natural

Here are three pictures of a wax likeness of Fidel Castro. The first shot is a natural light shot, using a shutter speed of 125th second, an f-stop of f/4.5, and an ISO of 800. Notice the dark areas under his eyebrows. The second picture, with the hard shadow, is obviously a flash picture. In the last shot, even though I balanced the light from the flash with the available light, you can still tell it's a flash picture. Notice the dark areas under Fidel's eyebrows are now brighter, but the sides of his head are now darker than in the natural light shot.

So whenever possible, try to use natural light for a more natural looking picture.

Outdoor Flash Techniques

One of my most important outdoor photography accessories is my flash unit. Without it, I'd miss capturing wide contrast in scenes. If set properly, a flash can compress the scene's brightness range—if the range is not exceedingly wide.

In this lesson, we'll take a look at a few outdoor flash pictures—technically called daylight fill-in flash pictures, because the flash fills in the shadowed areas. To balance the light, you'll need a variable output flash (I use a Canon Speedlite 580 EX) or a camera with built-in flash control.

In looking at these examples, try to keep in mind outdoor situations in which you could have used a flash for improved results. You can easily see the difference in these two images.

Read on!

Croton-on-Hudson, New York

Croton-on-Hudson, New York

Balancing Act

Check out the owl in these two pictures—if you can! Because humans see a brightness range of about 11 f-stops, my eyes could clearly see the owl. But my digital camera can only see about 5 stops. (See lesson 5 for more on what we see versus what our cameras can record.)

The shot in which you can actually see the owl is my flash picture. I used my technique for daylight fill-in flash (see lesson 6), as well as a

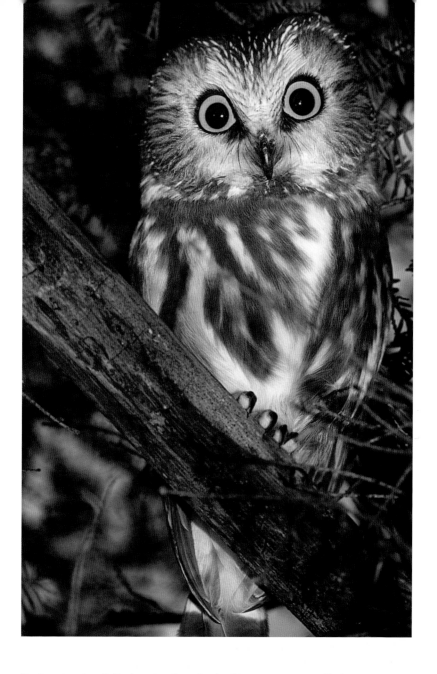

flash extender. A flash extender attached to an accessory flash narrows the beam of light and extends its range. For distant outdoor subjects, a flash extender is a must.

Off-Camera Flash Technique

One of my favorite flash photography expressions is: "Take the damn flash off the camera!" By taking the flash off the camera—either by holding it with your hand or by mounting it on a bracket—you can get more creative lighting effects. You'll need a coil cord to keep your flash connected to your camera, and your camera must have a flash connector (a hot shoe or flash socket).

Here is one example of how taking the flash off the camera helped me get a good shot. This dancer is actually standing in a parking lot, welcoming guests to the hotel. Behind the dancer is the hotel wall. To "erase" the wall, I took the flash off the camera, held it higher than the dancer's head, and tilted it slightly downward. This caused the light from the flash to fall directly behind her, but not on the wall—as would have happened if I had shot straight on with the flash mounted on my camera. Experiment with different angles to see how much you can get out of your flash when you have this additional flexibility.

Bangkok, Thailand

Flash Pictures at Sunset and at Night

Want to use city lights or a sunset as a backdrop for a portrait? If you have a camera with a Night Portrait mode, it's easy. A slow shutter speed is selected to capture the nightlights or sunset, and the built-in flash automatically pops up (or you can activate an accessory flash) to light your subject. This mode is perfect when you want to get a good exposure of both the subject and an illuminated background.

If your camera does not have Night Portrait mode, Manual exposure or Aperture is the way to go. First, dial in the correct f-stop and shutter speed combination for a correct exposure of the background. Then activate your flash and take a shot. You'll probably need to set the flash exposure compensation on the camera or the flash to –1. If the subject is too dark, increase the flash exposure, and vice versa.

Check your camera's LCD display to make sure both the background and the subject are correctly exposed.

Shootin' in the City

We all enjoy photographing in cities around the world, inspired by the people, places, and sights.

All photos in this lesson were taken in New York City.

However, I encourage you to spend some time shooting in your own city, or a city close to home. It's a great way to spend the day and exercise your creativity without having to travel far.

If you are new to city shooting, I've got some ideas to get you going. To illustrate, I'll use some photographs that I took in New York City, which is close to home for me!

Here's my first tip: Have fun! Sure, we are serious about photography, but we should try to have some fun with our photos. It's exciting to work with a subject to create a picture that will bring a smile to someone's face. As you can see in both of these photographs, I was having a blast during my photo sessions, a feeling reflected in the faces of my subjects. If you are having a good time, so will your subjects.

Think Wide-Angle

You'll need a fairly wide wide-angle lens to photograph buildings or statues from close distances. For this shot I used my 16–35 mm zoom set at 16 mm. Notice how the foreground element adds a sense of depth to the photograph.

Add More Interest

Create a sense of disequilibrium in a picture by tilting your camera to the side. This is a popular effect in music videos and television commercials. In this case, adding disequilibrium also helps tell a story—anyone who has ever ice-skated for the first time at Rockefeller Center can relate to this scene.

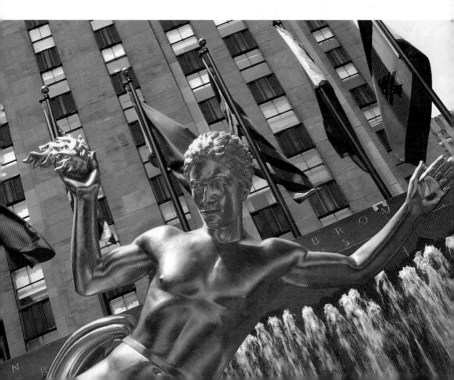

Look for Urban-Style Backgrounds

Many cities have building walls painted by local artists. Use these outdoor canvases as a backdrop for your photographs. Here I used my

28–135 mm zoom set at about 100 mm. For people pictures, a zoom setting around 100 mm will provide a nice camera-to-subject working distance.

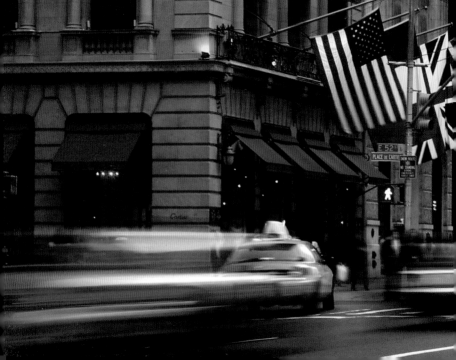

Slow It Down

To capture a city's hustle and bustle, use a slow shutter speed (1/15th of a second or slower) to create a sense of motion. At slow shutter speeds, you'll need a tripod to steady the camera. To prevent camera shake, use a cable release or your camera's built-in self-timer. Keep in mind that long shutter speeds often result in increased noise in a digital picture. Some cameras offer built-in noise reduction—a feature that you need to activate manually. Noise reduction takes several seconds, so you need to wait a bit longer before taking the next picture.

Bring a Flash Outdoors

Shadows created by buildings and trees can darken a subject's face. Use a flash to reduce or eliminate the shadows. I took this shot with my camera set on Program and my flash set at –1 1/3. The reduced flash output filled in the shadows for a daylight fill-in flash photograph. Because the flash output was reduced, it balanced the natural light and the result does not look like a flash picture. Read more about daylight fill-in flash in lesson 6.

Get Closer

In cities filled with the strong vertical presence of buildings, as well as constant surrounding visual activity, most people don't get close enough when they frame a subject. When composing a picture, think about how moving in or zooming in could improve it. For this picture, I zoomed in closer on Brook, standing in the LOVE sculpture. The photo may cut out more of the surrounding context, but it results in a more visually compelling photo than the one on page 212.

Get It All in Focus

Photographs of city scenes work best when most, if not all, of the scene is in focus. To achieve that goal, use a wide-angle lens, a small f-stop, and focus one-third of the distance into the scene. For this picture I set my 16–35 mm zoom lens at 20 mm, my f-stop to f/11, and focused on the red part of the carriage.

Close-Ups

Nature offers more fascinating beauty if we take the time to look closely.

Close-up photographs allow us to capture a unique view of our world, especially when that world is viewed at larger than life-size.

Capturing small subjects, such as a red-eyed tree frog, or a bumblebee on a morning glory, requires careful attention to the technical aspects of photography: focus, lighting, sharpness, depth of field, exposure, and composition.

For newcomers to the fascinating, fun, and rewarding aspects of close-up photography, this lesson covers a few of the basics.

We'll begin by taking a look at some pictures that were taken with my Canon EOS 1Ds, 50 mm, 65 mm, and 100 mm macro lenses, and Canon ringlight. We'll conclude with two examples that illustrate how we can use wide-angle lenses and natural light for close-up photography, too.

The Macro Lens Advantage

Zoom lenses with close-up settings are adequate for some close-up photography. However, if we want to get much closer to a subject, we need a 50 mm, 65 mm, or 100 mm macro lens. Even when we zoom all the way in to our subject with a zoom lens, all we have really done is reduce the focal length and with it the angle of view down to the point where the subject fills the frame.

A macro lens has a fixed focal length and shallow depth of field, but is designed to magnify the subject so it will be captured at a 1-to-1 ratio or better. Many macro lenses offer 2-to-1 or even 5-to-1 enlargements of the subject.

This picture of the scales on a butterfly's wing was taken with a 65 mm macro lens.

Extreme Close-Ups

This picture of the caterpillar of a faithful beauty moth was taken with a Canon MP-E 65 mm macro lens, which offers tremendous magnification. It's a specially designed, manual focus lens that actually lets us fill the frame with subjects as small as a grain of rice.

This lens's unique lens design actually lets us get much closer to a subject than a 50 mm macro lens, which lets us get closer to a subject than a 100 mm macro lens. So when photographing very small subjects, this particular 65 mm macro lens is the way to go for a stunning full-frame image.

Compose Carefully

Macro lenses and close-up settings on zoom lenses exaggerate the effects of camera shake. To reduce the chance of a blurry picture, most noticeable in natural light pictures, be sure to use a tripod.

Steady Your Shots

The background can make or break a close-up picture. Try to compose a picture so the background compliments the subject. The background should not be distracting. In this shot of a Portman butterfly, the green leaves set off the complimentary red of the butterfly's wings.

Add a Background

If the background is too distracting, change it by holding a black card behind the subject. A black T-shirt or piece of cloth works well, too.

Another technique is to photograph a leaf, make an inkjet print, and use the print as a background. For more creative control, try blurring the leaf in the digital darkroom (using Photoshop's Gaussian Blur filter) to simulate the effect of using different f-stops.

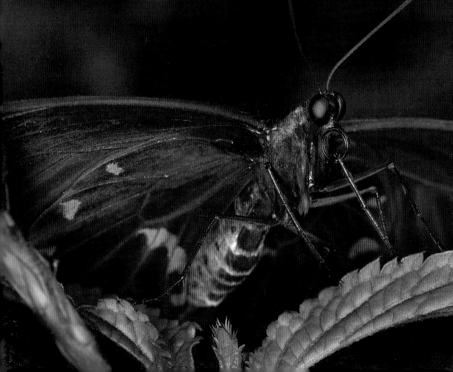

Add Light

When adding light to a close-up scene, a ringlight is a good choice. A ringlight fits on a lens and can provide side, top, bottom, and even lighting, because it has two flash tubes that surround the lens, each a semicircle. Turn on both flash tubes for even light. Turn off one light and rotate the ringlight for top, side, or bottom lighting.

The direct light from a ringlight also adds contrast to a picture, making it look sharper. I used a ringlight for this picture of a cabbage white butterfly.

Focus Carefully

In close-up photography, as in telephoto photography, focus is critical. We need to focus on the most important element in a scene, such as the eye of an insect or small animal. It's also important to shoot at a small aperture (f/11 or f/22) for good depth of field. I set my 50 mm macro lens at f/22 for this photograph and focused on the eye of the pink rose butterfly.

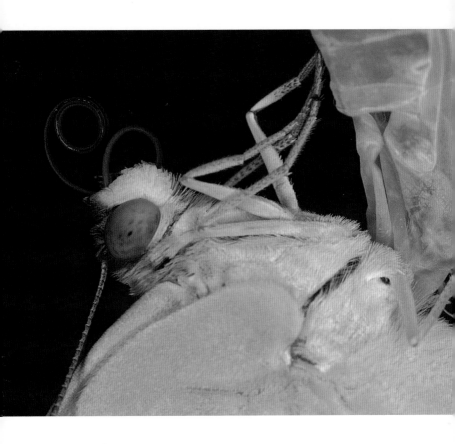

Use a Low ISO Setting

With digital cameras, as the ISO increases, so does the digital noise. I
always try to shoot at the lowest available ISO setting. My ringlight
allows me to shoot at ISO 100. This gives me a picture with no noticeable
digital noise—even in shadow areas, where noise often shows up.

Set the White Balance and Image Quality Settings

When using a ringlight, set the white balance to Flash. When the light is mixed (daylight and flash), set the white balance to Auto.

For the very best quality image, set the image quality to RAW (or at least Fine or High JPEG). The RAW setting may give you a little more exposure latitude, and therefore be more forgiving, than the Fine or High JPEG settings.

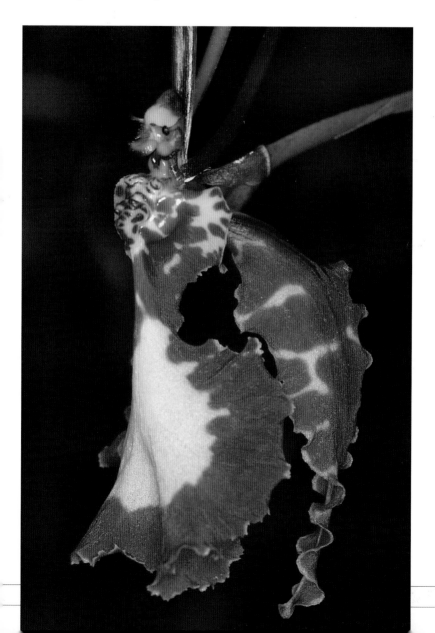

Go Wide

Wide-angle close-up photography has one advantage over macro lens close-up photography: much more depth of field.

Wide-angle lenses usually focus closer than zoom lenses with wide-angle settings. With both types of lenses, it's important to set a small aperture, focus carefully, and consider all applicable aforementioned tips. Keep in mind that ringlights can't be used for close-up wide angle photography, unless you want a very bright area in the center of the frame.

I photographed these blue roses in Mexico with my Canon EOS 1Ds and 16–35 mm zoom lens set at about 24 mm.

Have fun exploring the close-up world!

Check Your Exposures

Digital cameras are wonderful memory recording devices. They are also great teachers—showing you, on the LCD monitor, what you did right and what you did wrong—seconds after you take a picture.

Croton-on-Hudson, New York

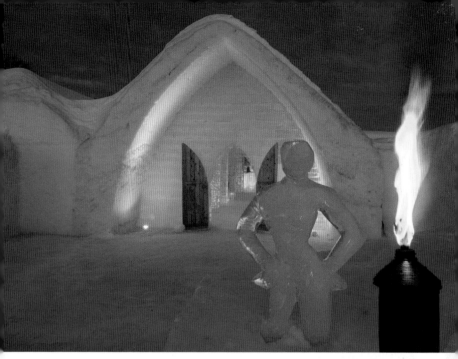

Ice Hotel, Quebec

Novice photographers use the LCD monitor to check composition and facial expressions. As they get more and more into the art and craft of picture taking, they take full advantage of the LCD display, checking and then perhaps fine-tuning the exposure. That's what I did for the picture of a cabbage white butterfly resting on a flower in my backyard. The first exposure I took showed that the butterfly's wings were overexposed. Seeing the problem on the LCD monitor, I underexposed the second image, shown here, by half an f-stop.

In this lesson I'll give you an overview of the different ways you can check your exposures in-camera, which will help you get the best exposure for existing lighting conditions.

I say "the best exposure for the existing lighting conditions," because sometimes, in very high contrast situations, a single, perfect in-camera exposure is not possible. To get the nighttime exposure of the Ice Hotel you see here, I took seven exposures (over and under the average exposure setting), and then used High Dynamic Range in Adobe Photoshop to combine the images for a single good exposure.

Let's check out the different ways to check our exposures.

Camera LCD Monitors Display a JPEG Image

The first thing you need to know about your camera's LCD monitor is that it does not give you a 100 percent accurate rendition of your picture. Still, it does help you check exposure, which I'll get to in a moment.

For now, here is something very important to remember:The image you see on the LCD monitor is for a JPEG file—whether you shoot JPEG or RAW. That's important, because even if the LCD monitor tells you that a RAW picture is slightly over- or underexposed (again, we'll get to that soon), you may be able to rescue the highlight or shadow areas in Adobe Photoshop Lightroom, Camera RAW, or Photoshop. A JPEG file has a smaller exposure latitude than RAW files, and so the display on the LCD monitor will reflect the limitations of a JPEG.

Don't Believe Your Eyes

Compare these two flash pictures of a butterfly resting on an orchid. On my camera's LCD monitor, the background looked pretty much the same in both pictures—very dark. Knowing the monitor's limitation, however, I suspected that the lighted background might be visible in the picture, which indeed was true when I viewed the image on my monitor at home.

To be on the safe side, I reduced my exposure (setting a faster shutter speed and a smaller f-stop) to reduce the amount of available light entering my camera. The picture with the digital frame, added in PhotoFrame Pro 3 from onOne software, shows the effect I had in mind: the beautiful orchid and butterfly against a jet-black background.

The moral of the story: Don't always trust what your eyes see on the LCD monitor.

American Museum of Natural History, New York

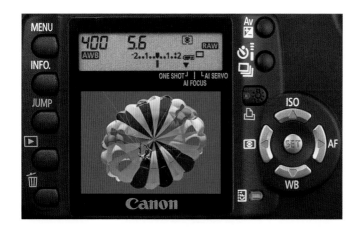

Set the Brightness Level on Your LCD Monitor

Here's another thing you need to know about your camera's LCD monitor: You should set it at the medium brightness level and then leave it alone. If you set the brightness level too low, your pictures will look too dark, and you may make exposure decisions that will cause your pictures to be overexposed when you open them on your computer monitor. If you set the brightness too high, you will face the opposite problem. So even if you are tempted when taking pictures outdoors on a sunny day to set the brightness levels to high so you can see your picture, take a deep breath and leave the brightness alone.

Your Camera's Overexposure Warning

Let's talk about a really useful feature of the LCD monitor: the overexposure warning. This warning comes in handy when you are photographing a high-contrast scene or a scene with bright areas, such as the sky in this picture of me crawling on the ice in the Sub-Arctic.

When activated (you can choose to have the warning active or inactive), potentially overexposed areas of a scene flash on and off rapidly (here the overexposed area is matted in pink and outlined in red). When that happens, you need to reduce the exposure—or use a flash, diffuser, reflector, or neutral-density filter.

Cape Churchill, Manitoba

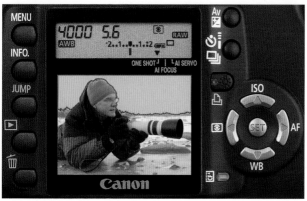

Invaluable Warning

In the picture of me crawling on the ice, it's easy to realize that the sky is much brighter than the shivering subject (it was –35° F). In my picture of this Native American, potentially overexposed areas, such as the white features on the man's outfit, may be harder to identify. In situations like that, the overexposure warning is invaluable.

Lake Powell, Arizona

Hurray for the Histogram

All digital SLRs and some compact digital cameras have a histogram display. The histogram, which often looks like a mountain range, is a graph that shows the distribution of the brightness levels in the picture, with the light areas indicated on the right and the dark areas indicated on the left. Some cameras display only a monotone histogram (for all the tones in a picture), while others feature a much more accurate three-color histogram, which shows the distribution of the brightness levels in the red, green, and blue channels in a picture.

Here's the basic histogram concept: Generally speaking, you don't want a spike at either end of the histogram. If you have a spike on the right, some highlights will be washed out, and you should decrease your exposure. If you have a spike on the left, some shadows will be blocked up, and you should increase your exposure.

The histograms for this mother and child image show that I have a good exposure for this scene—no spikes at either end of the histogram.

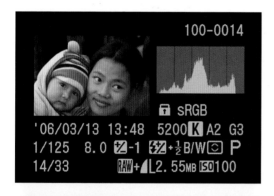

Bhutan

There's No Such Thing as a Perfect Histogram

I took this nighttime photograph through the front window of a Tundra Buggy in which I was traveling on my way to photograph polar bears. Due to all the dark and light areas, the histogram for this image is all over the place. To me, the picture is still properly exposed.

When looking at your histogram, please keep in mind that there is no such thing as a perfect histogram.

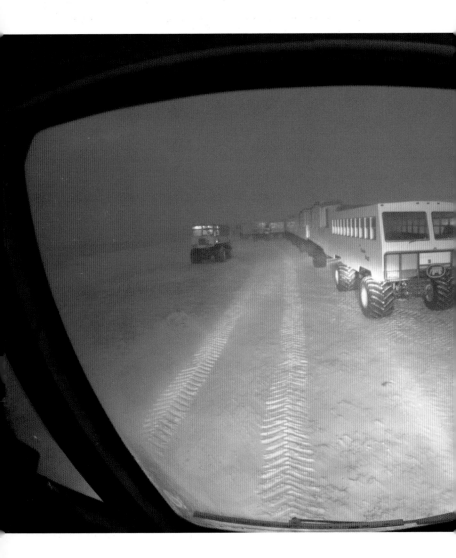

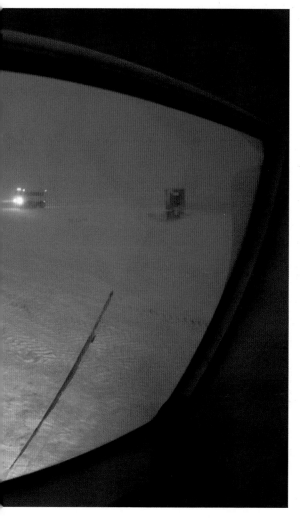

Cape Churchill, Manitoba

Shooting in the Snow

Taking pictures in the snow is cool, relatively and figuratively speaking. But snow scenes present certain photographic challenges. First and foremost, all that white can fool a camera's exposure meter into

Cape Churchill, Manitoba

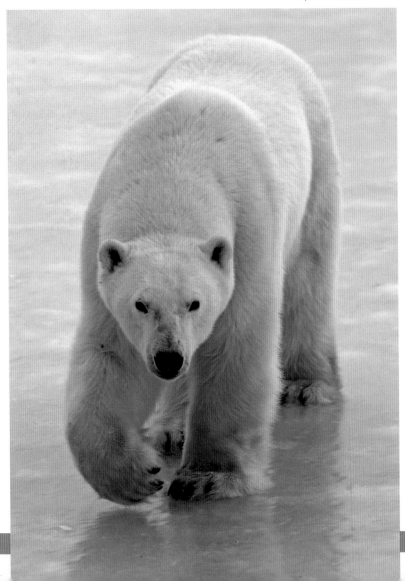

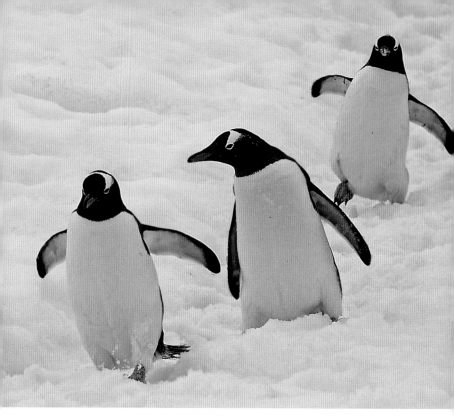

Antarctica

thinking that the scene is brighter than it actually is, setting up the camera for an underexposed picture. The remedy: set your exposure compensation dial to +1. That should give you a better exposure, which of course you can fine-tune further with additional exposure compensation.

Second, on overcast days, you have to deal with low contrast. When you are out there shooting, keep in mind that you will probably want to increase the contrast of the image in Photoshop. But be careful: Increase the contrast too much and the bright parts of the snow will be washed out.

Unless you are looking for a dreamy, soft picture, you'll also probably want to increase the image's sharpness. Be careful about over-sharpening, which can make a picture look pixelated.

Both of these pictures, the polar bear and the penguins, were the best in-camera images I could manage, later enhanced in Photoshop.

Let's chill out and check out some more tips.

Pack a Polarizing Filter

When the sun is shining, you do not, I repeat, *do not* want to go out on a snow shoot without a polarizing filter. A polarizing filter continuously varies the amount of polarized light that passes through it. In doing so, it can darken a blue sky, make white clouds appear whiter, and, most important in snow shooting, reduce glare on snow and ice.

A polarizing filter is most effective when the sun is off to your left or right. It is ineffective when you are shooting toward or away from the sun.

When using a polarizing filter, remove your skylight or haze filter. That will help prevent vignetting, especially when using wide-angle lenses.

I used a circular polarizing filter for both of these iceberg pictures.

Off the coast of Antarctica

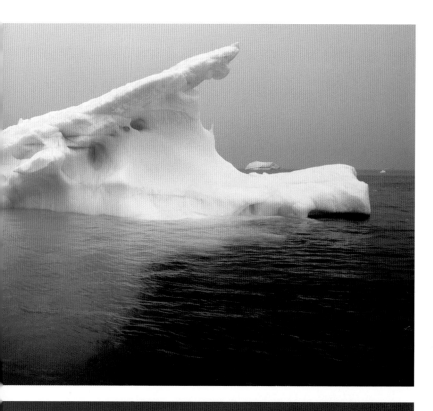

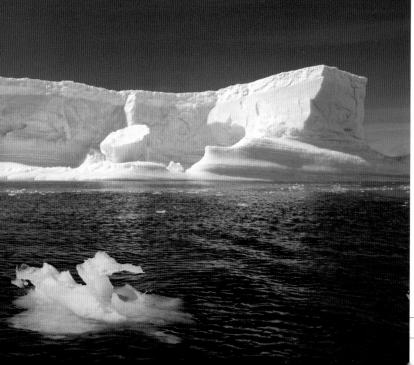

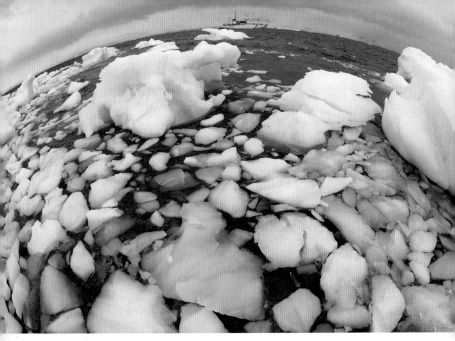

Antarctica

Bundle Up!

Dressing for success, bundling up in this case, helped me photograph this ice field. I was wearing Wellingtons, knee-high waterproof boots. I was also dressed in a warm parka and wore windproof gloves to keep my trigger finger relatively warm.

Had I been cold and miserable, I would have been in a bad mood and perhaps not inspired to take this picture, possibly my favorite from this expedition.

No matter what the weather conditions, always dress for success.

Keep 'Em Warm

In addition to keeping your body warm, it's essential to keep your camera and extra batteries warm. Cold temperatures suck the life out of batteries faster than you can say, "I'm freezing."

Keep your camera inside your coat until you want to shoot, and keep plenty of extra batteries in your pants or shirt pockets, close to your body.

I took this picture of an iceberg while riding in a Zodiac that was cruising through ice water. The temperature felt well below freezing, but by keeping my camera and batteries warm, I was still able to shoot.

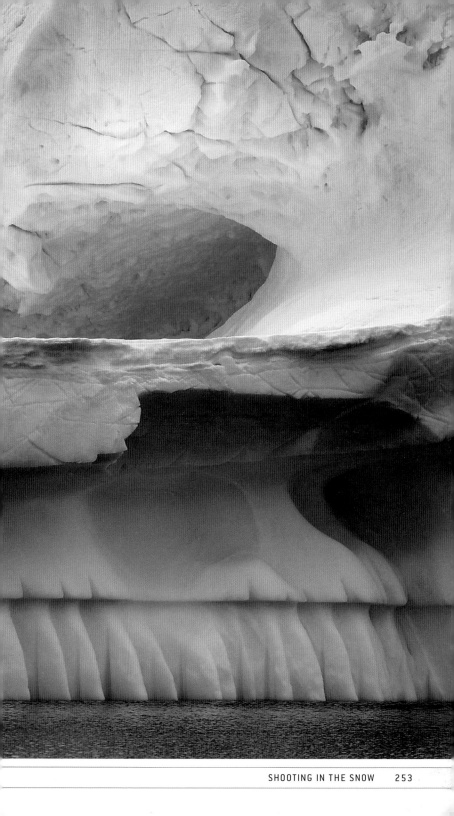

Ice Hotel, Quebec

Cape Churchill, Manitoba

Watch for Washouts

When photographing white and white, especially in bright light, you need to be very careful not to overexpose the scene's highlights, the brightest part of a subject.

After you take a shot, check your camera's histogram and make sure you don't have a spike on the right, which indicates a highlight washout. Also check your camera's overexposure warning, which shows overexposed areas as flashing on-and-off zones. (For more on checking your exposure, see lesson 14.)

When I took these two pictures I checked my camera's LCD display to make sure I had a good histogram and that I had not overexposed areas.

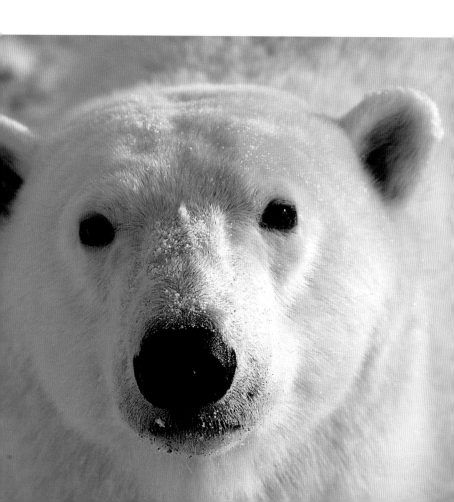

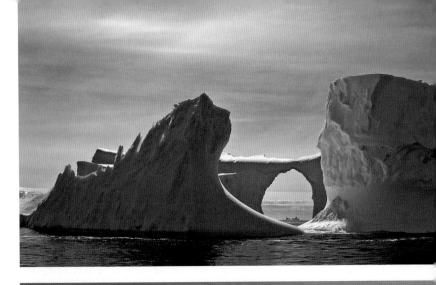

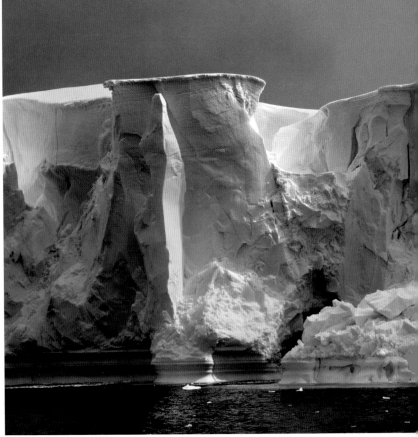

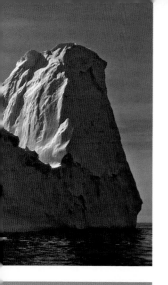

Think Black-and-White

Oftentimes snow scenes are monochromatic. If your camera has a black-and-white mode, take a black-and-white picture to see how the scene looks as a grayscale image. Even if it looks great, take a color shot, because you may want full color later. In Photoshop, you can convert your color image to black-and-white and make a better print, with more tones than can be created in-camera.

I created these black-and-white images from color files in Photoshop using Channel Mixer and the Monochrome setting.

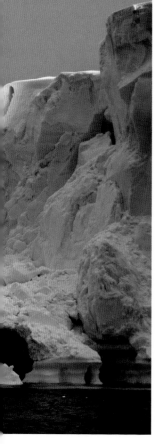

Antarctica

Envision the End Result in Photoshop

I put together this guide so that you'd have some good information at your fingertips when you are out shooting in the field. I am sure some of you will take your laptops, loaded with Adobe Photoshop or some other image-editing program, along with you on your travels. After a day's shooting, you'll probably work on and play with your images on your computer.

Kuna Yala, Panama

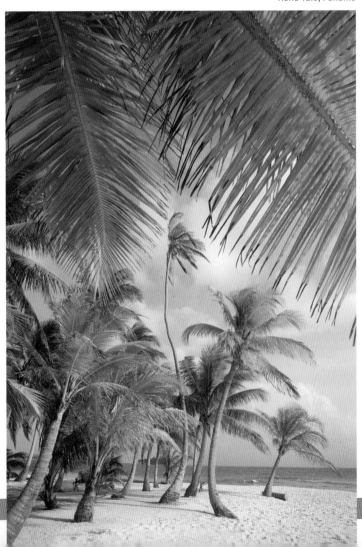

To keep this book small, I really can't include tips designed specifically for Photoshop. So for now I'd like to share with you a before-and-after. I took this picture on a small island in Kuna Yala, Panama. What you see on the left is an unprocessed RAW file. After processing the image in Adobe Camera RAW and then in Photoshop, using standard imaging-enhancing techniques, the picture to the right looks much more colorful and vibrant. What's more, the horizon line is curved and the leaves at the top of the frame are angled in the second image. I did that with Photoshop's Warp tool.

When you are out in the field shooting, always keep the end result in mind—don't forget what you can achieve in the digital darkroom.

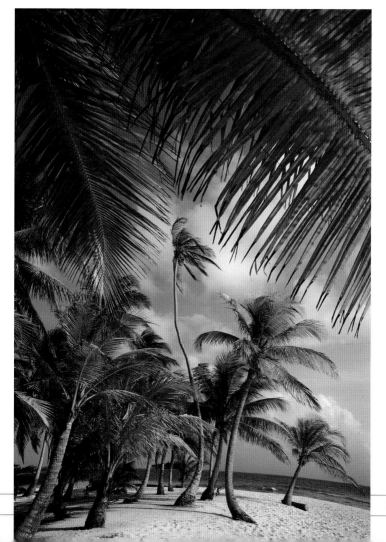

Closing Thought

I know it sounds simple, but having an interesting subject, such as this Huli Wigman posed by a remote waterfall in Papua New Guinea, is important in the making of a good photograph. For example, a photo of me watering my lawn in my shorts would not be as interesting as this exotic-looking image. Seek out interesting subjects, and they will draw interest to your photographs.

Good luck and have fun with your photography!

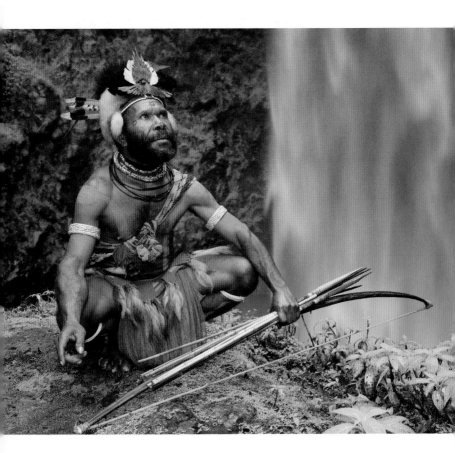

Glossary

Compiled by Joe Farace

Adjustable program: On automatic exposure cameras, a feature that lets the user change either the lens aperture or the shutter speed at the touch of a button or dial.

AI Focus AF: In cameras such as Canon's EOS 1D and D60, this is an autofocus mode that automatically switches from One-Shot AF to AI Servo AF when a subject moves.

AI Servo AF: Continuous autofocus mode with focus tracking and shutter priority, used for taking pictures of moving subjects.

Aperture: The size of the opening in the diaphragm of a lens through which light passes. Also known as an f-stop.

Aperture Priority mode: The automatic exposure mode in which the user sets the aperture and the camera automatically sets the appropriate shutter speed to produce a correct exposure. It is often used in landscape photography to produce greater depth of field by choosing small apertures.

Autofocus (AF): Automatic, motorized focusing.

Autofocus sensor: A sensor that determines where the lens is set for correct focus.

Average metering: Through-the-lens (TTL) exposure metering that takes into consideration the illumination over the entire image.

Bit (binary digit): Computers represent all data—including photographs—using the numbers 0 and 1. These numbers are called bits. *Note*: In a computer, each electronic signal is one bit; complex numbers or images are represented by combining these signals into larger, 8-bit groups called *bytes*. When 1,024 bytes are combined, you get a *kilobyte*. When you lasso 1,024 kilobytes, you have a *megabyte* (MB), usually shortened to "meg." And 1,024 megabytes are called a gigabyte (GB), or "gig."

Bit depth: See Color depth.

Bracketing: The technique of taking additional exposures that are over and under a "normal" exposure setting to ensure that a desired exposure is achieved from the several frames exposed. It is often used in tricky lighting conditions.

Bulb mode: An exposure mode that keeps the shutter open (or activated in digital cameras) for as long as the shutter release button is held down. Often used in nighttime photography for long exposures.

Byte: A combination of electronic signals into an 8-bit group.

Cable release: A cable device that allows for the remote release of the shutter. Helps prevent camera shake.

Card reader: A device for transferring pictures from a memory card into a computer.

CD-R (compact disc recordable): A CD on which you can write new data only once.

CD-ROM (compact disc read-only memory): A disc that resembles a music CD but can hold all kinds of digital information, including photographs.

CD-RW (compact disk recordable writable): A CD on which you overwrite data many times. These disks cost more than CD-Rs.

Coil sync cord: An extension cord for an accessory (shoe-mount) flash unit that permits off-camera flash. It allows for more creative photography, because you can control the specific direction of the light instead of producing the flat "flash-on-camera" look.

Color depth: Sometimes called "bit depth." A measurement of the number of bits of information that a pixel can store, which ultimately determines how many colors can be displayed at one time on your monitor. Also used to describe the specifications of devices such as scanners and digital cameras, as well as a characteristic of an image file.

Compression: A method of removing unneeded data to make a file smaller without losing any critical information or, in the case of a photographic file, image quality.

Continuous autofocus: An automatic focusing system that constantly tracks a moving subject. Useful in sports and action photography for keeping the principal subject in focus.

Contrast range: The difference in intensity between light and dark areas in a scene. High contrast scenes are difficult to expose correctly.

CPU (central processing unit): This powers your computer, although many cameras and lenses also have built-in CPU chips. Digital imagers need to have enough computing power to handle the kind, and especially size, of image they are working on. Shooting wildlife or sports is possible with a 50 mm lens, but the photographic experience will be much better—and less frustrating—when armed with a 400 or 800 mm lens. Similarly, choosing the right computer is first a matter of finding one with enough power to process digital images fast enough to minimize frustration and expedite creativity.

Daylight fill-in flash: The process of balancing the light from a flash with the available daylight.

Density range: The difference between the minimum and maximum tonal values that film or a digital camera's image sensor can register.

Depth mode: On Canon EOS cameras, a mode that lets the user take two distance readings (one of a near object and one of a far object), after which the camera sets the appropriate distance setting for maximum depth of field.

Depth of field: The distance of acceptable sharpness that is in front of and behind a specific focus point.

Diffuser: A device that diffuses, or softens, harsh sunlight for a more pleasing effect. Useful in outdoor portraiture.

Digital camera: A camera that records a picture using an image sensor (CCD or CMOS) to record images.

Digital noise: Appears as "grain" in digital image files. As a camera's ISO setting increases, digital noise also increases. Noise is also caused by slow shutter speeds in low-light conditions.

Digital sensor: The computer (imaging) chip inside a digital camera that captures an image.

Digital zoom: Not a true optical zoom lens, but rather a technique for enlarging part of the image sensor's frame. Not as sharp as an optical zoom.

DVD: Originally this meant digital video disc, but there has been movement by some marketing mavens (although not much) to change the name to digital versatile disc. Unlike the 600+ MB capacity of CD-ROM discs, DVDs can store 4.7 GB or more on a single disc that is the same physical size. While competing formats exists for writable DVDs, this has not stopped a number of companies from installing writable DVD drives in computers or offering them as external peripherals. It is just a matter of time before the DVD format replaces *all* disc-based data media, including CD-ROMS and music CDs.

EI (exposure index): The rating at which a photographer actually exposes a specific kind of film, therefore deliberately underexposing or overexposing it. This is accomplished by changing the camera's or hand-held meter's ISO film speed to reflect a number different from that recommended by the manufacturer.

E-TTL (evaluative through the lens): Flash-exposure metering used by Canon EOS film and digital cameras.

EV (exposure value): A numeric value used to describe the exposure. A variety of shutter speed and aperture combinations can produce the same exposure with a constant film speed: for example, 1/250 (of a second) + f/2 = 1/125 + f/2.8 = 1/60 + f/4 = 1/30 + f/5.6 = 1/15 + f/8, etc. *Note:* This is different from *exposure index.*

Exposure compensation: A feature found on both film and digital cameras that lets the user compensate (plus or minus) in an exposure setting in relatively small increments, such as one-half or even one-third of an f-stop to produce the desired exposure.

Exposure latitude: The contrast range that a specific type of film or digital image sensor can record.

Filter: A piece of glass or optical plastic that fits over a camera lens for a creative, protective, or corrective effect. Digital filters (Elements-compatible plug-ins) are also available for image enhancement and correction after a photograph has been captured.

Fixed focal-length lens: A lens with only one focal length, unlike a zoom lens which offers selectable focal lengths.

Flash extender: A device that attaches to an accessory flash that extends the flash's range. Useful in sports and wildlife photography.

Flash socket: A port on a camera that allows a cable from an off-camera flash or professional studio light to be attached.

Focal length: Measured in millimeters, the length of a lens.

Focus tracking: An automatic focusing system that tracks a moving subject. Useful in sports and action photography.

F-stop: A measure of the size of the opening in a lens calibrated to a corresponding focal length. These numbers are typically stated as f/1.4, 2, 2.8, 5.6, 11, 16, 32, etc. Large f-stops (e.g., f/2.8) allow a lot of light to enter the camera. Smaller f-stops (e.g., f/22) allow less light to enter the camera.

Gaussian Blur: An Adobe Elements filter that gets its name from the fact that it maps pixel color values according to a Gaussian curve, which is typically used to represent a normal or statistically probable outcome for a random distribution of events and is often shown as a bell-shaped curve.

GIF (graphics interchange format): A compressed image file format that was originally developed by CompuServe Information Systems and is platform-independent, meaning that a GIF file created on a Macintosh is also readable by a Windows graphics program. Pronounced like the peanut butter.

Gigabyte (GB): A billion bytes or, more accurately, 1,024 megabytes.

Grain: Coarse dots that you can see in a picture. As the film's ISO increases, grain also increases.

Grayscale: A series of gray tones ranging from white to pure black. The more shades or levels of gray, the more accurately an image will look like a full-toned black-and-white photograph. Most scanners will scan from 16 to 256 gray tones. A grayscale image file is typically one-third the size of a color one.

Hot shoe: Slot on the top of many cameras into which a portable flash unit is attached.

Hue: The attribute of a color by which it is discernible as red, green, or blue, as determined by its dominant wavelengths.

Icon: The little "pictures" that represent files, programs, or actions that are used in operating systems such as Macintosh OS or Microsoft Windows.

Image-editing program: A software program that allows digital photographs to be manipulated and enhanced to produce effects similar to those that could be produced in a traditional darkroom.

Image-writing speed: Speed at which a camera can write an image to memory card (or memory stick or CD).

In-camera exposure meter: An electronic device inside a camera that measures the reflected light level measured through the lens and helps determine the correct exposure for the film or digital imaging sensor.

Incident light meter: A handheld light meter that measures the light falling *on* a subject.

Inkjet printer: A type of printer that sprays tiny streams of quick-drying ink onto paper to produce high-quality output. Circuits controlled by electrical impulses or heat determine exactly how much ink—and what color—to spray, creating a series of dots or lines that form a printed image.

IS (image stabilization): Technology on Canon EOS lenses, called VR (vibration reduction) on Nikon lenses, that reduces camera shake.

ISO: Speed rating for film and equivalents (in digital cameras) that measures light sensitivity. The higher the ISO number, the greater the light sensitivity.

JPEG (Joint Photographic Experts Group): Method of compressing and storing photographic image files. JPEG was designed to discard information the eye cannot normally see and uses compression technology that breaks an image into discrete blocks of pixels, which are then divided in half until a compression ratio of from 10:1 to 100:1 is achieved. The greater the compression ratio that's produced, the greater the loss of image quality and sharpness. Unlike other compression schemes, JPEG is a "lossy" method. By comparison, the LZW compression method used in file formats such as TIFF is lossless—meaning no data is discarded during compression.

K: In the computer world, 2^{10}, or 1,024. A kilobyte (or KB) is, therefore, not 1,000 bytes but 1,024 bytes.

Landscape (mode): An image orientation that places a photograph across the wider (horizontal) side of the monitor or printer.

LCD (liquid crystal display) screen: Preview panel on a digital camera that shows the photographs that have been captured, along with other data.

LED (light emitting diodes): Provide information in a camera's viewfinder, such as flash-ready and focus confirmation.

Lens flare: Hot spot in a picture that is caused by direct light hitting the front element of the lens and reflecting through all of the other glass elements in a lens.

Lens hood: A device that fits over the front of a lens to help reduce and possibly prevent lens flare.

Macro lens: A lens specifically designed for close-up photography.

Manual mode: An exposure mode that requires the user to set both the shutter speed and f-stop.

Megabyte (MB): Used to describe file size. A megabyte is one million bytes of information.

Megapixel: Refers to the number of millions of pixels in a digital camera's image sensor. A 4 megapixel camera has an image sensor with 4 million pixels.

Memory card: Removable device used by digital cameras on which pictures are stored.

Montage: An image in which two or more different images are combined.

Motor drive sequence: Setting on a camera that allows pictures to be taken in rapid succession. Useful in situations in which there is a great deal of action.

Oversaturation: Has occurred when the colors in a picture are too vibrant and artificial.

Panning: The process of following a subject from left to right (or vice versa) in the viewfinder as it moves past the photographer. Using a slow shutter speed, the photographer takes an exposure (or several exposures) when the subject is directly in front of him or her. The result is a picture in which the background is blurred (streaked) and the subject is sharp, creating the feeling of motion and speed.

Photo CD: Eastman Kodak's proprietary digitizing process, which stores photographs onto a CD-ROM. The photo CD process can digitize images from color slides and black-and-white or color negatives; a master disc can store up to 100 high-resolution images from 35 mm film. Images on a photo CD are stored in five different file sizes (and five different resolutions).

Picture CD: A Kodak process that converts film-based images into digital files, using the JPEG format, and places them on a CD-ROM. This service can be ordered when you have your film processed by camera stores and other retail outlets.

Pixel (*picture element*): One of the thousands of colored dots of light that, when combined, produce an image on a computer screen. A digital photograph's resolution, or image quality, is measured by the width and height of the image as measured in pixels.

Plug-in: A small software application that is an "add-on" and that expands the capabilities of Elements or any compatible image-enhancement program.

Polarizing filter: A filter that can reduce glare on water, glass, and foliage. It can also darken a blue sky and whiten white clouds. Is not effective with metallic surfaces.

PPI (pixels per inch): See Resolution.

Processor chip: A chip in a digital camera that processes digital information.

Program mode: An exposure mode on a camera that automatically sets both the aperture and shutter speed for a correct exposure.

RAM (random access memory): That part of your computer that temporarily stores all data while you are working on an image or a letter to Granny. Unlike a floppy disk or hard drive this data is *volatile*. If you lose power or turn off your computer, the information disappears. Most computer motherboards feature several raised metal and plastic slots that hold RAM chips in the form of DIMMs (double inline memory modules). The more RAM you have the better it is for digital-imaging work; there are economic considerations, too. As I write this, RAM is inexpensive, but like the media itself, prices can be volatile.

RAW file: Minimally processed data from the image sensor of a digital camera or scanner. RAW files are much larger than JPEG files and must be converted to an RGB format before further manipulation. Many camera RAW files have a greater bit depth than JPEG files, which allows RAW files to accept minor exposure correction more readily than JPEG.

Red-eye: In dark conditions, an effect caused by light from a camera's flash reflecting off the blood vessels in the back of the eye. It can be reduced by making the room brighter, by using an off-camera flash, or by utilizing the red-eye reduction mode that some cameras and flashes offer.

Reflector: A device used to bounce (reflect) light onto a subject. Useful in outdoor portraiture.

Resolution: The number of dots per inch (dpi) or pixels per inch (ppi) that a computer device, such as a printer or monitor, can produce. A digital photograph's resolution, or image quality, is measured by the image's width and height as measured in pixels. The higher the resolution of an image—the more pixels it has—the better its image quality. An image with a resolution of 2,048 x 3,072 pixels per inch has better resolution and more photographic quality than the same image digitized at 128 x 192 pixels.

Ringlight: A ring-shaped device that fits over a lens for even or ratio lighting in macro and close-up photography.

ROM (read-only memory): That memory in your computer that you can only *read* data from. It's a one-way street.

Saturation: A measurement of the amount of gray present in a color; the degree to which a color differs from white.

Self-timer: A setting on a camera that allows a delay in the release of the shutter. Useful to avoid camera shake at slow shutter speeds.

Shutter lag: The time delay between the pressing of the shutter release and the actual taking of the picture.

Shutter Priority mode: An exposure mode that lets the user choose the shutter speed while the camera automatically selects the appropriate aperture for a correct exposure.

Shutter speed: The actual length of time the shutter is open (or the digital image sensor is activated).

Skylight filter: A filter that reduces the blue cast in pictures, most noticeable when using daylight-balanced slide film. Also protects the front element of a lens from scratches and dings.

SLR (single-lens reflex): In an SLR camera, the image created by the lens is transmitted to the viewfinder via a mirror and the viewfinder image corresponds to the actual image area.

Spot metering: An in-camera metering mode that takes a reading of a small area in a scene. Useful when the subject is in a high-contrast setting.

Teleconverter: A device that fits between the lens and the camera to multiply the focal length of the lens.

Telephoto lens: A lens that, in effect, brings the subject closer. Useful in wildlife, portraiture, and sports photography.

Thumbnail: Small, low-resolution version of an original image.

TIFF (tagged image file format): A bitmapped file format that can be any resolution and includes black-and-white or color images. TIFF files are

supposed to be platform-independent, so files created on your Macintosh can (almost) always be read by any Windows graphics program.

TTL (through-the-lens): A metering system in which the camera measures the actual light entering the lens.

Unsharp Mask: In Adobe Elements and other image-editing programs, a digital implementation of a traditional darkroom technique in which a blurred film negative is combined with the original to highlight the photograph's edges. In digital form, it's a controllable method for sharpening an image.

Variable-output flash: A flash that lets the user control the amount of light. The intensity of light can be increased or decreased for specific effects.

Vignetting: The process in which edges of pictures are lightened or darkened.

Warming polarizing filter: A filter that combines the effect of a warming filter and a polarizing filter. Often used in landscape photography.

White balance control: A feature on a digital camera that lets the user set the camera for the existing lighting conditions, such as sunny, shady, flash, florescent, and incandescent.

Wide-angle lens: A lens that takes in a wide view. Useful for landscape photography.

WYSIWYG (what you see is what you get): The ability to view text and graphics on screen in the same way that they will appear when printed. Pronounced "wizzy-wig."

Zoom: A tool found in most image-enhancement programs that lets you zoom into any photograph by clicking your mouse button. Zoom is depicted by a magnifying glass icon so often that it's often just called "magnifying glass."

Zoom-lens reflex (ZLR) camera: A digital camera with a built-in (noninterchangeable) zoom lens.

Acknowledgments

If you are reading these acknowledgments, you are probably looking for your name and for some nice things that I might have said about you. Or you may be interested in seeing who is on my thank-you list for helping me with this book. Well, many people have helped me with this work, as well as with my photography career. If you are one of them, I hope I remembered to properly thank you in this section. If you don't see your name here, please drop me an e-mail and remind me of my temporary memory loss. I'll be sure to remember to get you into my next book!

My first thank-you goes to Leo Wiegman, who signed me up for five books at W. W. Norton. Leo is great editor—but more important, a great friend. Jennifer Cantelmi at W. W. Norton handled most of the editing for this book and made the process fun—making work fun is a talent. Lisa Rand gets a thank-you, too! She helped Jennifer along the path to editing her first book.

Other folks at W. W. Norton who get my thanks are: Bill Rusin, Tom Mayer, Devon Zahn, Carole Desnoes, Nancy Palmquist, and Don Rifkin.

My dad, Robert M. Sammon Sr., who, among other things, taught me how to take pictures with a Linhof 4x5-inch view camera, read all my lessons and offered advice. My son, Marco, helped me with some of the photographs. And my wife, Susan, never complained when I announced that I was taking off for places like Mongolia, Antarctica, or the Subarctic to take pictures.

Julieanne Kost, Adobe Evangelist, gets a big thank you for inspiring me to get into Photoshop in 1999. Addy Roff at Adobe also get my thanks. Addy has given me the opportunity to share my Photoshop techniques at trade shows around the country.

Some friends at Apple Computers—Don Henderson, Fritz Ogden, Kirk Paulson, and Ann Townsager—also helped me during the production of this book by getting me up to speed with Aperture 2, which speeds up my digital imaging workflow.

Other friends in the digital imaging industry who have helped in one way or another include David Leveen of MacSimply and Rickspixelmagic.com; Mike Wong and Craig Keudell of onOne Software; Rob Sheppard and Wes Pitts of *Outdoor Photographer* and *PCPhoto*; Ed Sanchez and Mike Slater of Nik Software; George Schaub, editorial

director of *Shutterbug*; Kelly Mondora of F. J. Westcott; Kriss Brunngraber of Bogen Imaging; Scott Kelby of *Photoshop User*; and Chris Main of *Layers*.

At Mpix.com, my online digital imaging lab, I'd like to thank Joe Dellasega, John Rank, Dick Coleman, and Richard Miller for their ongoing support.

Rick Booth, Steve Inglima, Peter Tvarkunas, Chuck Westfall, and Rudy Winston of Canon USA have been ardent supporters of my work, as well as my photography seminars. So have my friends at Canon Professional Service. My hat is off to these folks, big time! The Canon digital SLRs, lenses, and accessories that I use have helped me capture the finest possible pictures for this book.

Jeff Cable of Lexar hooked me up with memory cards (4GB and 8GB because I shoot RAW files) and card readers, helping me bring back great images from my trips.

My photo workshop students were, and always are, a tremendous inspiration for me. Many showed me new digital darkroom techniques, some of which I used in this book. During my workshops, I found an old Zen saying to be true: "The teacher learns from the student."

So thank you one and all. I could not have done it without you!

Index

filters:
 blur, 42
 graduated, 170–71
 natural density, 38–39, 242
 noise reduction, 42
 polarizing, 19, 38, 168–69, 250
 skylight, 169, 250
 warming, 19
flash, 17, 82, 87, 100, 103, 157, 242
 backup equipment for, 190–91
 bracket mounting for, 186
 built-in, 210
 daylight fill-in, 108–09, 110, 112, 142, 204–10, 220
 exposure compensation and, 210
 extenders for, 28, 207
 indoor shooting with, 22, 184–91, 202
 in jungles, 23
 for lighting birds' eyes, 28
 off-camera techniques with, 208
 red-eye and, 186–87
 reducing shadows with, 13, 185, 186
 and reflections on glass, 188
 ringlight, 225, 233, 234, 235, 236
 at sunset and night, 210
 swivel head, 22
 underexposing white subjects and, 188
 for underwater photography, 35
 variable output, 13
 variable output control for, 108–9
flash diffusers, 103, 106–07, 186, 242
flash sockets, 208
focusing:
 autofocus, 199
 in close-ups, 233, 236
 with wide-angle lenses, 174–75, 222, 236
"focus on the eyes," 127
foreground, in landscape photography, 144, 174–75
frame advance settings, rapid, 9, 120
f-stop settings, 230
 for available light indoor shooting, 202
 background focus and, 94
 for close-ups, 233, 240
 for maximum depth-of-field, 160–61, 174
 for shooting birds in flight, 147

for underexposure, 81, 180, 239
 with wide-angle lenses, 222

glass, reflections on, 19, 188, 199
graduated filters, 170–71
grayscale images, 257
guides and translators, 68–69, 96, 130, 132

hard drives:
 more RAM vs. more storage capacity, 46
 portable, 5
high altitudes, 73
highlights, 80, 90, 138, 255
histogram displays, 245, 246, 255
home practicing, 29, 78
horizon, 156–57, 259
horizontal shots, 37
hot shoes, 157, 208

image-editing programs, 31
 familiarity with, 55
 RAM and, 46
image processors, 30–31
image quality settings, 235
image rescue software, 3
image sensors, 166, 193
 full-frame, 161
 heat and humidity and, 20
 light reaching the corners of, 30
 sand on, 15
image stabilization, 193
in-camera deleting and formatting, 4
indoor shooting:
 with available light, 192–202
 with fast lenses, 197
 flash and, 22, 184–91, 202
 ISO setting and, 22, 193, 197, 200, 202
 shutter speed and, 22, 193, 194, 200, 202
 of stage shows, 200
 tripods and, 22, 201
 white balance and, 198, 199
 wide-angle lenses and, 194
Internet searches, 47, 69
ISO settings:
 for available light indoor shooting, 193, 197, 200, 202
 for close-ups, 234
 digital noise and, 39, 133–35

About the Author

Photograph by Susan Sammon

Rick Sammon has published 30 books; his latest include *Rick Sammon's Travel and Nature Photography*, *Rick Sammon's Complete Guide to Digital Photography 2.0*, *Rick Sammon's Digital Imaging Workshops*, *Rick Sammon's Exploring the Light*, and *Flying Flowers: The Beauty of the Butterfly*.

Rick writes for *PCPhoto*, *Outdoor Photographer*, *Layers* magazine, photoworkshop.com, and photo.net.

Rick has several online classes at Kelbytraining.com, including Digital SLR Basics, On-Location Photography, Photoshop 3-Minute Makeovers, Exploring Digital Photography, and the Business Side of Photography.

Rick gives more than a dozen photography workshops and presentations around the world each year. He presents at Photoshop World, which he says is a "blast."

The host of the *Canon Digital Rebel Personal Training Photo Workshop* DVD, Rick is also the author of the Canon Digital Rebel XT lessons on the Canon Digital Learning Center and a Canon Explorer of Light.

When asked about his photo specialty, Rick says, "My specialty is not specializing."

See www.ricksammon.com for more information.